BREWING IN MANCHESTER AND SALFORD

DEBORAH WOODMAN

AMBERLEY

Acknowledgements

This book has allowed me to write about a further aspect of the Manchester region's heritage. The concept of a book on local brewing caught my interest while undertaking my PhD several years ago and I am delighted to have finally fulfilled this ambition. Over the years, I have been struck by the quality of research undertaken by local historians whose work has been prolific and here I must mention the publications by Neil Richardson and Alan Gall, who have made a major contribution and influenced the direction of my writing. I also wish to thank Anthony Groves of the Groves & Whitnall Brewery family for his interest in this project.

I would like to thank the following people/organisations for permission to use copyright material in this book: Anthony Groves, Manchester Archives & Local Studies library, Salford Local Studies & Archives, Tameside Local Studies & Archives, National Library of Scotland, Alamy, the Brewery History Society, St Ann's Church, manchesterpostcards.com, and Mike Serigrapher, Steven Robertson, and Bernt Rostad on Flickr. Every attempt has been made to seek permission for copyright material used in this book. However, if I have inadvertently used copyright material without permission/acknowledgement, I apologise and will make the necessary correction at the first opportunity.

First published 2024

Amberley Publishing
The Hill, Stroud
Gloucestershire, GL5 4EP

www.amberley-books.com

Copyright © Deborah Woodman, 2024
Maps contain Ordnance Survey data.
Crown Copyright and database right, 2018

The right of Deborah Woodman to be identified as the Author of this work has been asserted in accordance with the Copyright, Designs and Patents Act 1988.

ISBN 978 1 3981 1331 2 (print)
ISBN 978 1 3981 1332 9 (ebook)

All rights reserved. No part of this book may be reprinted or reproduced or utilised in any form or by any electronic, mechanical or other means, now known or hereafter invented, including photocopying and recording, or in any information storage or retrieval system, without the permission in writing from the Publishers.

British Library Cataloguing in Publication Data.
A catalogue record for this book is available from the British Library.

Typesetting by Amberley Publishing.
Printed in the UK.

Contents

	Acknowledgements	2
1	Introduction	4
2	The Emergence of the Local Brewing Industry	6
3	Around North Manchester	10
4	Ardwick and Hulme	43
5	Around South Manchester	52
6	Salford	64
7	Twentieth Century and Beyond	79
	Notes	92

1

Introduction

Manchester and Salford, two cities whose heritage is intricately entwined, are known for their industrial history, focussing on nineteenth-century textiles where 'King Cotton' loomed large and other industries that supported this, such as engineering, dominated both the local and national economy. However, other industries have not received much attention and this book seeks to address this by looking at one of these sectors, namely its thriving brewing industry, and here we embark upon a journey of its development from the late eighteenth century to recent times. Trends in the local brewing industry broadly developed in line with that at a national level, except for London spearheading changes ahead of the provinces, in a complex relationship between public houses, publicans, and commercial brewers. Originally, publicans brewed beer for sale on their singular premises but a combination of legislative control, technological development, and increasing economic competition all conspired to shift the single publican brewer away from the brewing function into a retail-only occupation. The domination of commercial brewers, whose business was as much about the property as the beer, meant that they acquired public houses and other breweries at an often alarming rate. The history of the industry reveals a process that was driven by economies of scale as urban areas and populations expanded with a consequential demand for beer, and legislation that tried to control the drink trade, sometimes with startling consequences such as that of the 1830 Beer Act, which was a pivotal moment in the history of drink culture that will be explored.

Some of Manchester and Salford's famous brewing names, such as the popular Boddingtons, who originated as Caister & Fray, one of Manchester's first commercial brewers from the 1770s, and became the 'Cream of Manchester' in the twentieth century, fell victim to takeovers, a trend that has dominated the industry for the last couple of centuries. The story begins with the emergence of the local brewing industry and its transition from pub brewing to commercial production. The history of the early key brewers in the region is surveyed, including Boddingtons through its former ownership by Caister & Fray in 1778 and the Joule family in Salford a decade later. Into the nineteenth century, more commercial brewers appear and some of the famous names that are associated with the region, such as Joseph Holt, Hydes, Chesters, and

Introduction

Wilsons in Manchester and Salford-based Groves & Whitnall and Threlfalls, all make their mark. Two further brewers on the fringes of central Manchester, J. W. Lees at Middleton Junction and Frederic Robinson of Stockport, are included since their influence in Manchester and Salford cannot be ignored. Several other brewery histories are featured as the shaping of the local brewing trade is explored.

As regards the beer itself, fashions in taste have changed over the last 200 years or so, from the original dark treacly porters to the lighter sparking pale ales. How beer is consumed has also been transformed, from the local draught brews conveyed by horse and dray through to the onset of refrigeration, bottling, and canning of beer products to extend the product's life and transport to new markets. Technological innovation and improvements to the transport infrastructure have both influenced the beer trade, from the ability to produce greater quantities, a wider variety of products, better quality, and geographically wider and faster distribution. These factors came together in the latter part of the nineteenth century to impact the industry to maximum effect. Equally, the influence of the brewers emerged around the home of British brewing, Burton upon Trent, in shaping the industry both locally and nationally, both in terms of it becoming a centre for innovation and its convenient location for all regions of the country.

The arrival of the twentieth century proved to be difficult for many local brewers. The turn of the century was marked by a poisoning scandal that devastated the industry; and further restrictive legislation, two world wars, and subsequent post-war reconstruction (or destruction, such was the effect of slum clearance) tested the survival of the local drink trade. Brewery takeovers continued, including Greenall Whitley's purchase of Groves & Whitnall; the merger of Threlfalls and Chesters, and their subsequent takeover by Whitbread; the takeover and ultimate disappearance of Wilsons; and the much-publicised acquisition of Boddingtons by Interbrew and the closure of Strangeways Brewery in the 1990s, all shaped the modern local brewing industry. Despite this, some old-established brewers, such as Joseph Holt, Hydes, J. W. Lees and Robinsons, that resisted takeover and only modestly engaged in takeovers themselves, have survived as independent brewers and retained their place in an industry dominated by conglomerates. The story comes full circle in the twenty-first century as small-scale businesses and localism have returned with a rash of microbreweries that utilise redundant spaces, such as railway arches, in a very productive way and are influencing what we drink, where we drink, and how we consume beer going forward.

2

The Emergence of the Local Brewing Industry

The story begins with the development of the brewing industry from the late eighteenth century and through the nineteenth century, a period shaped by legislation, such as the arrival of the 1830 Beer Act, technological development, and increased economic competition that led to wide-ranging changes in how the industry operated. In 1778, Caister & Fray arrived at the Strangeways Brewery, located in a district the brewery was named after and an area that later became associated with the famous Boddingtons name and the notorious prison next door. Manchester and neighbouring Salford were on the verge of huge transformations. The industrial process was taking hold and each town was rapidly growing, both in importance and size, to reflect their new industrial status and rising population, creating a market for beer and more pubs to satisfy the desire for a pint, especially among the working class who enjoyed this much-needed outlet after a tough day in the factory. Large-scale brewing had been a feature of the brewing industry in London from the early 1700s, but the provinces were mainly unaffected until well into the nineteenth century. Commercial breweries flourished in towns and cities where their customer base was within just a few miles since the delivery of beer, a perishable product that did not travel well, was confined to a horse-drawn dray.

The rise in commercial brewing in Manchester and Salford in part can be ascertained through trade directories. For example, between 1773 and 1797, the number of brewers doubled from five to ten in Manchester and Salford. It is also interesting to note that many of these brewers engaged in other trades, such as timber merchants and maltsters (someone who produces malt from barley to be used in the production of beer). Caister & Fray were both corn dealers and brewers, Thomas Crallan, located in Ardwick, was a tallow chandler (a candle maker) and soap boiler as well as a brewer, while Joseph Wrigley of Collyhurst owned a logwood mill.[1] In the nineteenth century, these rose further, from thirteen in 1818 to thirty-four in 1834. This was just four years after the 1830 Beer Act, which was arguably the most influential piece of legislation of its time and pivotal in attempting to divert consumers away from spirit drinking towards beer consumption in a belief that it would curb drunkenness. However, it failed miserably and resulted in an almost overnight explosion of beerhouses that just

served beer as it only required modest capital to obtain an excise licence and open premises. The key change here was in placing beerhouse licences outside the scope of magistrates' control, unlike public houses which were more heavily regulated. It led to hundreds of beerhouses sprouting up in urban areas, which created the opportunity for commercial brewing to flourish and for both beerhouses and commercial brewers to develop in tandem. Localities such as Ardwick, Hulme, and Salford saw a rash of brewers emerge to service this rapid expansion in beer drinking.

How had the brewing industry previously operated with few commercial brewers? The answer lies in the many single publican-brewers that produced beer for consumption in individual pubs. Contemporary newspapers that advertised the selling or letting of premises allow us to visualise what pubs looked like, the facilities they offered, any attached brewhouses, and their production capacity. For example, in 1843, the Cross Keys in Ancoats was reported as having a six-barrel brewhouse, and in the 1850s the Crown and Thistle, also in Ancoats, operated an eight-barrel brewhouse.[2] In 1860, the Church Inn on Chester Road, Hulme, the Hare and Hounds in Shudehill, and the Old Half Moon in Chapel Walks were all advertising brewhouses as part of their establishments.[3] These are just a fraction of examples found in the local press and this can be supplemented with data from parliamentary papers that offer a fuller picture of trends in beer production. Statistics for the Manchester Excise District show that in 1832 three-quarters of beer produced was by the single publican or beerhouse keeper, and a quarter by commercial brewers. By 1841, this had become even between the single publican/beerhouse keeper and commercial brewer, and by 1860 commercial brewers were producing the most beer output. By the turn of the twentieth century commercial brewers were producing all beer consumed in local pubs and beerhouses.[4]

Later in the nineteenth century, newspaper advertisements changed in format, with the focus being more on whether a public house was free from brewer tie-in rather than production from an onsite brewhouse. Former pub brewhouses were also being converted into different uses and rented out to other businesses. One of the earliest examples of this can be seen in 1825 when the Von Blucher public house parted with its onsite brewery.[5] Most other examples are later and include the former Griffin (later Land O' Cakes) and the Cotton Tree pubs, both in Great Ancoats Street, which were relinquishing their brewing function. By the mid-1840s, the Cotton Tree had separated the public-house function from its brewing to develop two separate businesses. The Bank of England pub in Ancoats began as a beerhouse, by 1841 was a fully licensed public house, and by 1847 had initiated a brewing function with at least one tied house, but by the 1860s the brewing function had become a separate business from the public house.[6] In 1860, the Old Blucher public house in Ardwick was offering 'all the building that used to be a brewhouse but is now a machine shop'.[7] The former Bridge Inn public house and attached brewery was originally a public house from the late 1830s with an attached brewhouse. Thomas Chesters of Chesters Brewery purchased this in 1859 and rented out the brewery as a separate business in 1861. This was originally known as the Bridge Inn Brewery and later became the Fairfield Brewery and here begins one of the key names in local commercial brewing.[8]

Much of this change was the result of legislation and technological development, which led to the rise in commercial brewing and the displacement of the publican from production to a retail-only role. The influence of the 1830 Beer Act is evident. The controversy and subsequent tightening of this legislation eradicated some of the more unsavoury aspects of the social consequences it created, by improving both the quality of beer and pub properties, which changed how the industry operated. Further legislation applied in 1834 and 1840 among other later bills was imposed to restrict the consequential explosion in beehouses that had led to a rise in drunkenness and social order concerns, such as that aired by the contemporary writer the Reverend Sydney Smith, who once famously said, 'the new Beer Bill has begun its operations. Everybody is drunk. Those who are not singing are sprawling. The sovereign people are in a beastly state.'[9] Social commentators Sidney and Beatrice Webb were also particularly critical of the system, arguing that the period up to the 1830 Beer Act was 'the most remarkable episode in the whole history of public-house licensing in England', whose regulation was seen to be 'deliberate and systematic' by magistrates.[10] Three further pieces of legislation tightened up licensing even further and included the 1869 Wine and Beer Act and the 1872 Licensing Act. These had the effect of returning control of beerhouses to magistrates by curbing their numbers and improving the quality of pubs and beerhouses that could not produce the volume of beer required to a suitable standard to meet demand and to the specifications the legislation required. They became dependent on commercial brewing companies for loans or tie-ins because the legislation imposed stricter controls on the industry which enforced higher standards in the upkeep of pub premises that landlords could often ill afford. The tighter licensing legislation imposed in 1869 increased pressure to improve the quality of both public-house premises and beer, which created additional financial burdens that both publicans and beerhouse keepers struggled to shoulder.

As commercial brewers increased in numbers, with the latest technology in their breweries, and increasing financial influence, they forged a role in manipulating the management styles of pubs as publicans became reliant on the investment they could provide. Publicans initially benefited from exclusive deals in which capital could be secured in a loan-tie arrangement that benefited both publican and brewer but later became consumed by the power the larger breweries had gained. By the end of the nineteenth century, commercial brewers were purchasing public-house properties at an alarming rate, which gave them control over the sale of their beer by securing a market for the products. At the turn of the twentieth century, almost all of Manchester's pubs were in the hands of breweries rather than individuals. The largest businesses controlled some hundreds of tied outlets, the smallest just one or two. This process included brewery takeovers where the more successful commercial brewers began to buy out smaller breweries, along with their portfolios of public houses, often by flotations on the stock exchange to raise capital to purchase more houses or merge with other breweries to form larger chains of houses and rationalise production. The purchasing of properties at a greater geographical distance from breweries began even when the logistics of this were barely viable, such was the level of competition. Efficient

local transport, refrigeration, and bottling of beer all became vital innovations for brewers servicing an ever-increasing portfolio of pubs with a perishable product at a greater distance.[11]

Next, the histories of some of the key brewers in the locality are examined to illustrate how these issues played out, revealing a complex network of relationships between brewers, where some survived but many did not.

3

Around North Manchester

This historical tour of local breweries starts in the area north of Manchester city centre, from J. W. Lees at the Greengate Brewery on the fringes of central Manchester, through Newton Heath and Cheetham Hill, to Boddingtons at the Strangeways Brewery on the edge of the city centre. Here we come across some of the biggest names in the industry both locally and nationally.

J. W. Lees, Greengate Brewery

This independent brewery, which is located on the outskirts of central Manchester, continues its influence and joins the likes of Hydes and Joseph Holt in its enduring legacy in the brewing trade. Today, the company is a sixth-generation family business which employs over 1,300 people, 140 at the Greengate Brewery and over 1,100 in their forty-three managed pubs, inns, and hotels.[1]

J. W. Lees originated in 1828 when John Lees, a retired cotton manufacturer, purchased the site that became the Greengate Brewery at Middleton Junction. John Lees senior was succeeded by his sons, John and Thomas, who expanded the brewery both in terms of licensed premises and increased output. They took control of the business after their father's death and the partnership lasted until Thomas passed away in 1854, leaving John as the sole proprietor. John died in 1869, and Thomas' sons, John William and a second Thomas, took control of the firm.[2]

Their joint ownership lasted until 1878 when Thomas died, and John William became sole owner. It was around this time that the reconstruction of the original brewery took place, coinciding with its fiftieth anniversary. The business continued under the management of John William, along with support from his mother and sisters, but by the mid-1890s, John William Lees was again the sole proprietor. It was from this point forward that the J. W. Lees name began and continues to this day. John, like many brewers of the time, became involved in supporting his local community, including chairmanship of several companies, and the presidency of the Middleton Literary and Scientific Society, and Middleton Agricultural Society. He was a magistrate for the borough of Oldham and became the first borough magistrate for Middleton.[3]

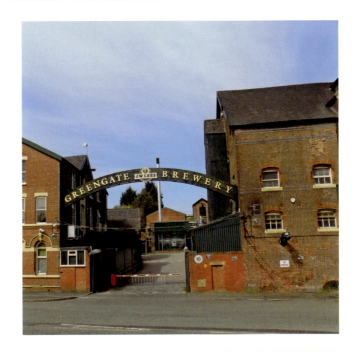

J. W. Lees, the Greengate Brewery.

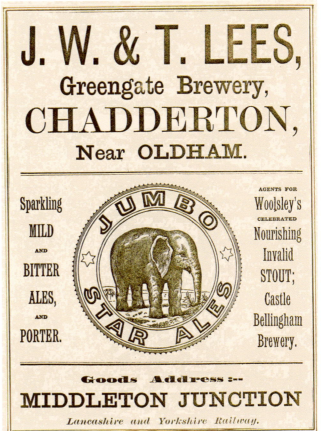

J. W. Lees advertisement, c. 1880. (Courtesy of the Brewery History Society)

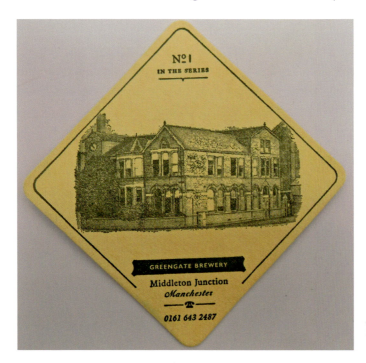

J. W. Lees beer mat illustrating the Greengate Brewery.

John faced some challenging times and around 1906 he became embroiled in a legal dispute. The issue began at the close of the nineteenth century and involved the purchase of the nearby Whitefield Brewery, managed by Arnold Briscoe, and the Longsight Brewery from the executors of Daniel Flattely, who had been at the Longsight Brewery from 1868 until his death in 1897, whose executors were negotiating a deal with Lees. However, John became entangled in a dispute with Briscoe who maintained that a formal agreement had been reached to form a merged company with the Stamford Brewery in Ashton-under-Lyne, the Lee Home Brewery in Oldham, and the financially stricken Whitefield Brewery. Lees disputed that such an agreement had ever been made and the full truth of the situation will never be known. A case was brought by shareholders of the Whitefield Brewery on a fraud charge, alleging that there had been incorrect statements and financial irregularities in the prospectus for the formation of the new company of Breweries Ltd in 1899. The picture is confusing. It was suggested that the Longsight Brewery's output and assets were artificially inflated and disputed at the 1903 shareholders' meeting, and it was this that led to Lees being charged with fraud and the company being issued with a winding-up order.[4] The court case was not until May 1906 and Lees struck a deal to compensate shareholders to avoid prosecution.[5] He finally acquired the Whitefield Brewery, which remained in financial difficulty despite being floated on the stock exchange to raise funds, along with the Longsight Brewery. In short, Lees came out of the ordeal reasonably well apart from a bruised reputation.

Within a year of the case, in January 1907, John died aged sixty-one. His three nephews, John Lees Jones, Richard Jones, and Adam Horrocks Hollingworth, were in line to take on the business when they reached eighteen.[6] J. W. Lees & Co. (Brewers) Ltd

was registered in 1936. In 1954, the chairman, by now John Lees-Jones, was attracted by an offer from Hammond's United Breweries as post-war trade had been difficult, but his brother Richard opposed the move and bought John out of the company.[7] By the end of 1955, a revised company with the same name was registered. A couple of years later, Richard Lees-Jones, a member of the fifth generation of the family, joined the business. The company continues to brew under the control of the latest generation of the family and is still located at the Greengate Brewery. In 2018, they celebrated 190 years in business.

J. W. Lees has produced a variety of interesting beers over the years including the strong, dark Moonraker ale. This first appeared in 1950 and was produced in recognition of a local legend about some farmers who after a long session in the pub staggered home and fell into a pond when they attempted to rake the reflection of the moon in the water, which they thought was a round of cheese.[8] It proved to be a strong beer with a sweet, fruity taste.[9] The brewery's core range includes bitter, Manchester Pale Ale, Founder's Premium Bitter, and Dragon's Fire, named in acknowledgement of the brewery's Welsh connections, since their portfolio of pubs and hotel stretch into North Wales. They also offer more specialised and seasonal brews including a

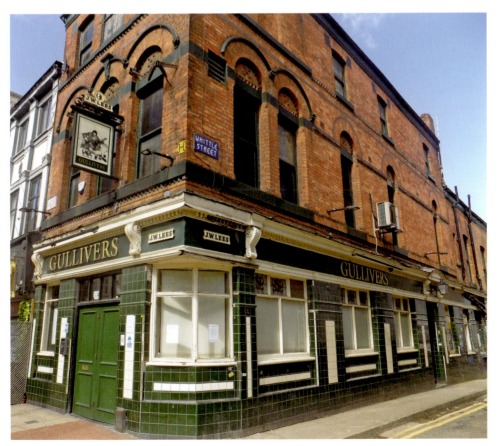

Gullivers public house, central Manchester, a J. W. Lees establishment.

A recent J. W. Lees beer mat.

A beer pump label illustrating the brewery's Welsh connections.

plum-pudding ale at Christmas, a golden ale at Easter, and a citrus-style summer beer. It also sells the Boilerhouse range from its microbrewery, which produces over fifty craft beers.

W. T. Rothwell, Heath Brewery

Moving closer to central Manchester, we now turn to the breweries at Newton Heath, the first of which is William Thomas Rothwell's Heath Brewery. Unfortunately, it no longer exists, but its origins can be traced back to the 1870s when William purchased a run-down brewery, and in doing so became not only a prominent brewer, but a pivotal political figure both in his local community and Manchester more generally. Sadly, in 1886, the Rothwell family faced tragedy when William's brother, Frederick, aged just thirty-three and who worked at the Heath Brewery, died when a wort pan boiled over and scalded him, highlighting that the industry was not without its risks.[10] The brewery developed rapidly and Rothwell started to make acquisitions, including the Bardsley Brewery near Ashton-under-Lyne in 1902 along with forty tied houses. Bardsley Brewery originated in 1832 and was at one time owned by Bentley & Carr, later becoming Shaw & Bentley before Rothwell's purchase. The Bardsley Brewery continued until the end of the First World War. After a period when the building was derelict, it was renovated and converted into apartments.

William began his local political career with a role on Newton Heath's Local Board, becoming the Conservative candidate for the Newton Heath ward, which he held until 1905 when he became an alderman. His other appointments included a spell as chair of the Brewers Central Association, and he was one of the Manchester Ship Canal's key supporters during its planning and construction. An advocate of

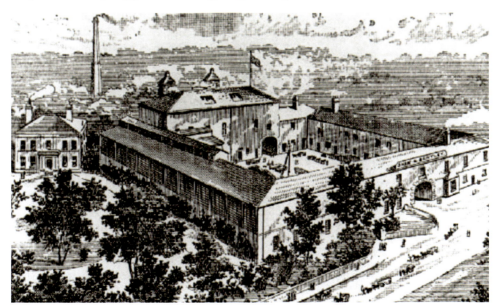

An early sketch of Bardsley Brewery, Ashton-under-Lyne. (Courtesy of Tameside Local Studies & Archives Centre)

Above and below: The former Bardsley Brewery today, which has been converted into apartments.

education, he was the founder of the Stanley Jevons Chair of Political Economy at Owens College (the modern University of Manchester). He resigned from Manchester Council in 1917 after twenty-seven years of service and relocated to Harrogate due to ill health. In 1917 the brewery became W. T. Rothwell Co. Ltd, with William as the main director. Sons Frank and Charles, who learned their trade at the brewery, also became directors. William died in 1921 aged seventy-seven. The brewery continued in Rothwell's name through Charles' son, Charles Maurice, until around 1960 when it was sold to Marstons Brewery of Burton upon Trent, together with eighty pubs and 120 off-licences. Brewing continued at Newton Heath until 1968 when the site was demolished.[11] Their brews included ordinary and best mild, bitter, and Mancunian Strong Pale Ale.

Wilsons, Newton Heath Brewery

The second and larger of Newton Heath's breweries was that of Wilsons, whose chessboard logo made their pubs and beer instantly recognisable. It began around 1834 in the industrial and working-class area just off Oldham Road. John Waddington had operated a glue factory in Monsall Lane which closed, creating an opportunity for John Collinson and George Simpson, who took on the premises and converted it into a brewery. The brewery quickly took off. It was extended in 1837 and by the early 1850s a further lease was secured to establish a larger brewery. Simpson died in 1862 and his sons ran the business until 1865 when they sold it to Henry Charles Wilson and Thomas Philpott. However, the partnership did not last long owing to Philpott's death within a year of joining the company. Wilson went on to become a key player in the local trade, having been a founding member of the Manchester Brewers Central Association, a predecessor of the Brewers Society, formed in 1869. In 1880, another lease was agreed upon for a larger plot of land close by which freed up the original site but allowed for the development of an even larger brewery. This included the buildings that still exist today, albeit in use for a different purpose.[12]

By 1884, Hubert Malcolm Wilson joined his father in the business, and just three years later, in 1887, Henry Charles died. Soon after Hubert took control the company began purchasing pubs and, by 1890, they had acquired almost fifty houses, most of which were between Manchester and Oldham. The purchase of the George public house in Market Drayton, Shropshire, was the first one outside the brewery's locality and initiated the geographical spread of their pubs. In 1894, the brewery became Henry Charles Wilson & Co. Ltd, along with the acquisition of a further sixty pubs.[13] Their expansion continued at a pace. In 1896, they obtained nineteen more pubs when they purchased the Stockport-based Joseph Worrall's brewery, and another forty-three houses through the acquisition of Oldham's Jowett, Waterhouse & Co.[14] In 1899, they purchased one of the largest breweries in Hulme, Cardwell & Co. Ltd at the Naval Brewery with around 120 houses and eleven off-licences, following its liquidation.[15]

The Naval Brewery was started by James Hargreaves in around 1850. It was passed to his son, who died in 1875, and then Cardwell and Renshaw acquired it.[16] It was also around 1850 that Joseph Cox began a brewery in Hulme. Cardwells &

WILSON & PHILPOTT,

(LATE COLLINSON & SIMPSON),

Porter, Ale & Bitter Ale Brewers,

NEWTON HEATH,

MANCHESTER.

AGENTS FOR

JOHN D'ARCY & SON'S DUBLIN PORTER.

A Wilson & Philpott advertisement, c. 1864. (Courtesy of the Brewery History Society)

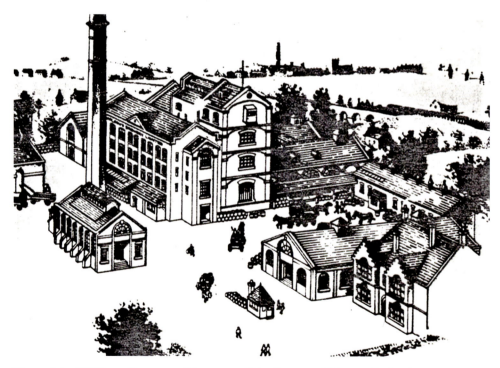

The original Wilsons Brewery. (Courtesy of the Brewery History Society)

Cox joined forces in 1894 and the brewing took place at the Naval Brewery. Their partnership was short-lived and in 1899 they went into liquidation, allowing Wilsons to purchase the brewery and around 120 public houses.[17] This transaction was also short-lived since, by 1900, Wilsons sold the Naval Brewery to the Salford-based brewer J. G. Swales.[18] Swales was another old-established brewer set up in the 1830s by James Wheater, and, by the 1890s, Swales joined the partnership and had become the sole proprietor by the turn of the twentieth century. The company continued at the Naval Brewery until 1971, when Boddingtons bought them out and the site stopped production.[19]

Wilsons continued with their acquisition plans into the early twentieth century and obtained more local breweries. These included Edward Issott's brewery at Ardwick from Edward's widow, with four pubs, thirty-five beerhouses, and various other properties. This was quickly followed by the purchase of Hulme's Kay and Whittaker at the Britannia Brewery in October 1903, together with sixty houses.[20] The Britannia Brewery was another well-known local brewery, dating back to the 1850s, and by 1883 it was under the occupation of William Kay. In early 1900, Kay merged with Richard Whittaker's Ardwick-based Victoria Brewery and the brewing was transferred to the Britannia site. Unfortunately, this partnership was short, since Kay passed away in March 1901, and Wilsons purchased the business a couple of years later.[21] The Britannia Brewery was particularly useful for Wilsons as they turned it into their bottling department. Wilsons also purchased a further six pubs from the trustees of the brewer George Handley.

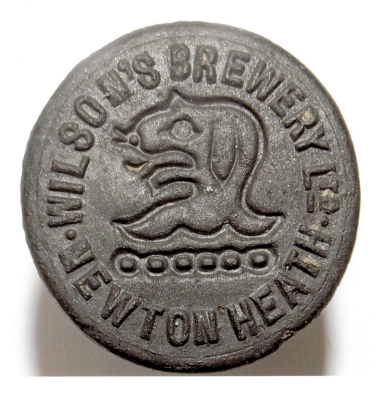

A Wilsons beer bottle stopper.

Above and below: The former Wilsons Brewery buildings.

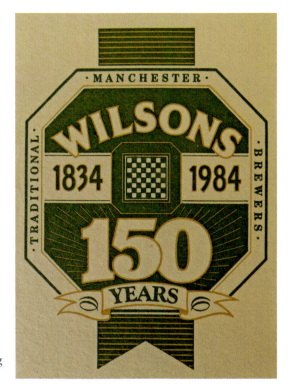

A Wilsons beer mat commemorating its 150th anniversary in 1984.

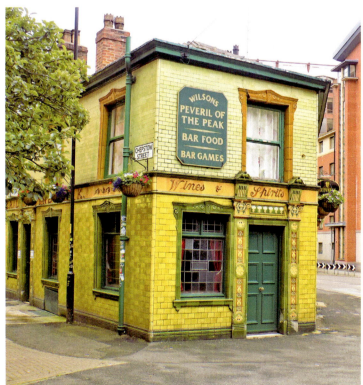

The historic Peveril of the Peak public house, central Manchester, formerly a Wilsons establishment.

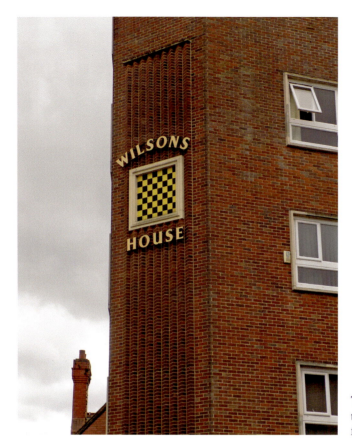

The chessboard trademark became famous for Wilsons.

In 1917, Hubert Wilson stepped down as chair of the company. During his tenure, he undertook several roles within the trade and community. In 1911, he was vice-chair of the Brewers Society, followed by chair in 1912–13, and vice-chair again until 1924. His roles set a precedent for the brewery's involvement in public life, since between 1912 and 1955, five chairs of the society came from Wilsons. Wilsons did not escape the impact of war, but this was more about trade than direct destruction. In around 1915, their trade started to decline, and pubs were closing at a brisk rate, with five pubs lost in this year alone.[22] They let out part of the Britannia Brewery to a soap factory to offset losses, but by 1918 this had also been sold.

The interwar period was one of slow but steady progress and pubs were acquired and lost in equal measure. In 1924, Wilsons took control of the Alfred Crowther Brewery of Bury, along with thirty-two houses, though many of these required investment and refurbishment. Soon after they introduced the chessboard branding that the company became famous for. In 1930, they purchased the Huddersfield-based Peter Marsland's Watergate Brewery, along with eleven pubs. War returned once more and following the Christmas Blitz of 1940, which damaged local brewery buildings, Wilsons stepped in to support both the Cornbrook Brewery and Groves & Whitnall. However, they did not escape unscathed, losing four pubs and four off-licences with further damage to forty-six pubs and twenty-five off-licences.[23]

The post-war era was an active time for mergers. In 1949, Wilsons merged with Salford's Walker & Homfrays Ltd, which came with its own prolific track record of takeovers, including B. & J. McKenna of Harpurhey, Watson, Woodhead & Wagstaffe Ltd, Manchester Brewery Co. Ltd (that itself had taken over five breweries between 1889 and 1899), and John Taylor & Co. Ltd of Ancoats. B. & J. McKenna existed for thirty-five years before Walker & Homfrays took control. Bernard McKenna began his career as a publican and small-scale brewer, and in the 1860s built the brewery. It became B. & J. McKenna Ltd in 1895 but was purchased by Walker & Homfrays ten years later. John Taylor's brewery followed a similar trajectory. Taylor was the publican of the Admiral Rodney public house during the mid-1860s and then went into brewing and, by the late 1870s, he was both a landlord and brewery manager. The brewing part of his business became known as the Pollard Street Brewery and in 1895 became a limited company.[24] By 1929, Walker & Homfrays had acquired the brewery and was there for around fifteen years until Taylor's brewery went into formal liquidation in 1943.

Walker & Homfrays were also instrumental in saving the beleaguered and badly managed Manchester Brewery Company. Established in around 1838 in Ardwick by William Nell, it was purchased by James Deakin in 1858, who remained at the brewery until his death in around 1888 when the Manchester Brewery Company purchased it along with 133 houses. However, after mixed fortunes, Walker & Homfrays took control in 1912 and saved the company. The merger between Walker & Homfrays and Wilsons in 1949 resulted in the new company being known as Wilson & Walker Breweries Ltd, but, by 1952, the company had reverted to its original Wilsons name.[25]

Above and right: Beer mats illustrating Walker & Homfrays. (Courtesy of the Brewery History Society)

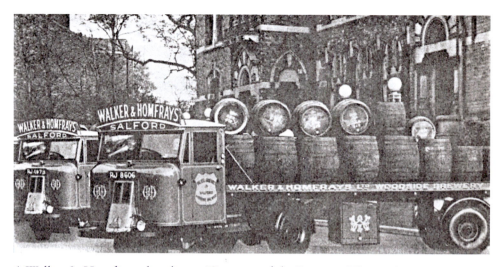

A Walker & Homfrays dray lorry. (Courtesy of the Brewery History Society)

The Manchester Brewery advertisement. (Courtesy of the Brewery History Society)

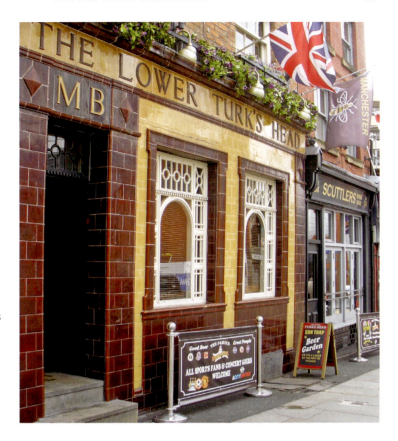

The Lower Turk's Head public house, central Manchester, displaying the former 'MB' Manchester Brewery signage.

The post-war modernisation and slum clearance of northern working-class neighbourhoods throughout the 1950s and 1960s resulted in Wilsons losing several properties. Likewise, plans to construct the Mancunian Way bypass through central Manchester in 1960 led to further losses. In 1957, Wilsons formed a collaboration with Watney Mann Brewery which involved selling their brown ale in Wilsons pubs. By 1960 this had become a formal amalgamation, but what at first appearances seemed a collaboration felt more like a takeover of Wilsons. Wilsons and Watneys went on to acquire the Beverley Brothers at the Eagle Brewery of Wakefield in 1967 and a year later the collaboration was keenly felt when a new company, Watney Mann (North) Ltd came into operation that co-ordinated business in northern England, Scotland, and Ireland. Arguably, these transactions had diminished brand identities. The Wilsons chessboard logo disappeared, as did the identity of their beers which became 'Great Northern Mild' and 'Great Northern Bitter'. Watney Mann was acquired by the Grand Metropolitan group in 1972. However, what seemed to be lost was regained in 1976 when the Wilsons brand name was re-established.[26] By the 1980s, though, Wilsons were effectively finished. Brewing ceased in June 1986 and for a while Wilsons beer was brewed in Halifax by Webster & Sons Ltd but marked the end of the company. During their peak, Wilsons offered a range of beers such as Wilsons Porter, Ale and 'Great Northern' Bitter, Olympic Pale Ale, Strong Ale, Wembley Ale, Wembley Extra Stout, and Top Brass Lager.

Boardman's Brewery

Here we find ourselves on the edge of central Manchester, in and around Cheetham Hill, which was the location of three distinct breweries. The first of these was Boardman's Brewery, the founder of which, William Boardman, began his brewing career as a publican at the Derby Arms public house from the 1850s until his death in 1877. By 1860, he had built a brewery on Cheetham Street. Boardman's Brewery continued after William's death, becoming Boardman's Breweries Ltd following the merger with J. Atkinson of Bolton in 1895 and the merger with several other breweries a year later, including E. A. Rothwell of Hulme and three Yorkshire breweries, which resulted in the amalgamation of 162 pubs and around forty-three off-licences.[27] In 1897, a new brewery was built in Hulme but it had gone into liquidation within three years due to the construction proving more costly than anticipated.[28] Boardman's local pubs were acquired by the Cornbrook Brewery. The brewery managed to keep going until 1950 when it was acquired by Tetley's Brewery and the site was sold.

Joseph Holt, Derby Brewery

Cheetham Hill is also the location of Joseph Holt, which is one of those rare and successful breweries that have stayed independent and within the same family and have managed the seemingly impossible in an industry dominated by takeovers. Joseph was born near Bury in 1813. His brewing career began in earnest during the 1840s when he took a job as a carter for Harrison & Co. at the Strangeways Brewery before Boddingtons took charge. It is believed that in around 1849 he began brewing at a pub somewhere around Oak Street in what is now the Northern Quarter of central Manchester and, having recently married, was living in nearby Mayes Street.[29] In 1855, he purchased the Ducie Bridge Brewery in Cheetham Hill from the established brewers Smalley & Evans.[30] Titus Smalley went on to purchase the Chorlton Road Brewery and was there until his death in September 1867.

By 1860, Joseph Holt's business was flourishing and he leased some land just off Cheetham Hill Road where he built the Derby Brewery along with his new home.[31] The following year he acquired the company's first pub, the Duke of Wellington in Eccles, and from here the brewery grew.[32]

Between 1861 and 1882, the year Joseph stepped back from the business, the brewery acquired approximately twenty pubs, averaging one or two per year. Of these, only one was within central Manchester: the Bricklayers Arms, close to the Derby Brewery. Joseph Holt was located just yards away from Boddingtons at the Strangeways Brewery but was never a serious rival to their neighbours in terms of output, producing at best 15,000 barrels per annum in 1878 compared with Boddingtons who were producing over 109,000.[33] However, progress was steady and assured. Joseph's son, Edward, joined the business in 1875 and assumed sole control in 1882, and four years later Joseph died. The 1880s and 1890s were important decades for the company's development, with their property portfolio increasing and the brewery being modernised, including the introduction of a bottling plant in 1901.

Edward Holt was a prominent figure in Manchester. He initially declined the offer to become Lord Mayor of Manchester in 1905 and much was made of the decision,

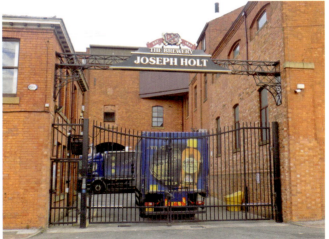

Joseph Holt's Derby Brewery, which remains on its original site.

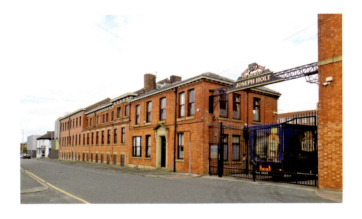

The former home of Joseph Holt is now part of the brewery offices.

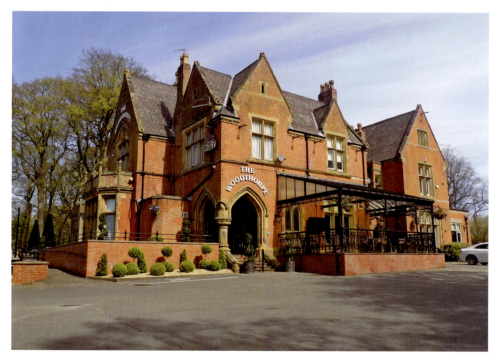

The Woodthorpe Hotel in Prestwich, the former home of Sir Edward Holt.

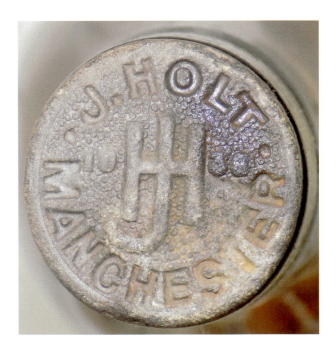

A Joseph Holt beer bottle stopper.

and despite Edward citing family reasons, the local press reported that the anti-drink lobby had influenced his decision.[34] However, he went on to become Lord Mayor of Manchester in 1908 and 1909. His other projects included a contribution to the establishment of the Manchester & District Radium Institute, which became pivotal in the treatment of cancer, and he was also involved in the Haweswater scheme to bring a water supply from Cumbria to Manchester. In 1916, he became a baronet and honorary freeman of the city and in 1920 he received a CBE.[35] He had also completed a spell as vice-president of the Manchester Brewers Association.

Wartime directly affected the brewery and during the First World War many members of staff and pub tenants were called up to the armed forces. Many failed to return, including Captain Joseph Holt, Sir Edward's son, who had been earmarked to manage the business but was killed at Gallipoli in 1915, aged just thirty-three.[36] The interwar period allowed the brewery to consolidate its position in the market and Joseph Holt Ltd was registered in 1922.[37] The company changed hands with Edward II taking over in 1928, the same year that Sir Edward I died suddenly, aged seventy-eight. By this time the company had grown to include eighty-four pubs and thirty-five off-licences.[38] War loomed once more and during the Christmas Blitz of Manchester in the Second World War the Derby Brewery came to the rescue of neighbouring Boddingtons, whose production was stopped at the Strangeways Brewery due to bomb damage.[39] The post-war period produced mixed fortunes. The company went public in 1951. However, redevelopment plans and slum clearance in Manchester and Salford led to Holt's losing around fourteen pubs to compulsory purchase between 1960 and 1974. One of these was the William IV pub in Salford, which closed in 1960, although the bar itself gained notoriety when it was moved to the set of the TV soap *Coronation Street* and became part of the 'Rovers Return' public house.

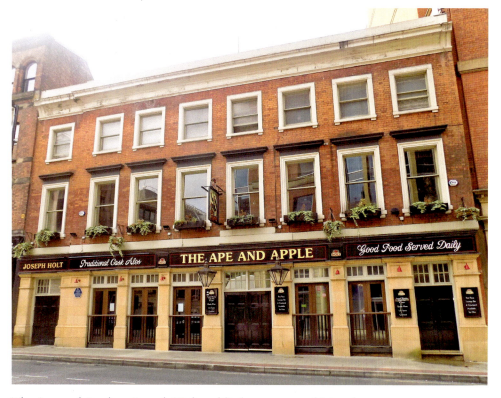

The Ape and Apple, a Joseph Holt public house, central Manchester.

A beer mat of the iconic fictitious Manchester Brewery 'Newton and Ridley' in the long-running soap *Coronation Street*.

Edward Holt II died in 1968, aged eighty-five, and the chair of the company passed to Peter Kershaw, Sir Edward's nephew. Peter's son, Richard (great-great-grandson of Joseph Holt), joined the board in 1980 and in 1985 became managing director. In 1999, the brewery celebrated its 150th anniversary but just a year later Peter Kershaw died.[40] Into the 2000s, the brewery has remained a successful family-based company that has received several awards for its beers. As well as its uncompromisingly hoppy mild and bitter, it has a fashionable IPA and a citrus/fruity golden ale called Two Hoots.

Joseph Holt was an early starter in lager production and its Diamond beer has won several awards, including the world's best in the prestigious International Brewing Awards in both 2013 and 2017. In 2019, head brewer Jane Kershaw, the great-great-great granddaughter of Joseph Holt, was named 'Brewer of the Year' by the Parliamentary Beer Club at a ceremony in Westminster.[41]

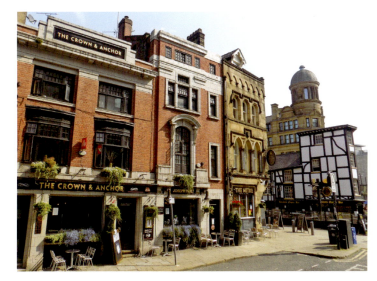

The Crown & Anchor, a Joseph Holt public house, central Manchester.

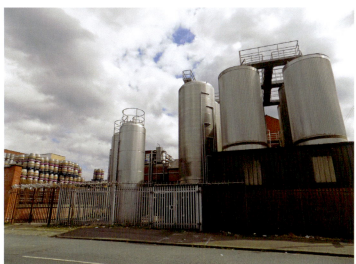

The modern plant behind the original brewery buildings.

Joseph Holt beer mats convey its northern roots and feature a distinctive play on words to advertise the quality of its beer over the years.

A Joseph Holt pump label advertising its award-winning HumDinger beer.

Boddingtons, Strangeways Brewery

'The Cream of Manchester' was one of the iconic television advertisements of its time, with the early 1990s portrayal of both beer and locality evident in the recruitment of local actress Melanie Sykes to showcase all that was good about Manchester, strong northern accent included. The reality was that around a decade later the cream very much left Manchester, both physically and metaphorically, when Interbrew (subsequently InBev) acquired the company, retaining the Boddingtons brand, which is still seen in pubs and supermarkets, but not necessarily the cult status the beer had in the city. The story began over 200 years earlier, and it is these days that will be fondly remembered here, from its tentative beginnings to the domination and success of the Boddington family. The start of the company is clear; in 1778, a date that has been proudly displayed on all its brewery memorabilia for almost two centuries, Thomas Caister and Thomas Fray established the business. Little is known of them, but during the last decades of the eighteenth century they were recorded in local trade directories as corn dealers and brewers, at a brewery in Strangeways and a warehouse in nearby Withy Grove. By 1800, their warehouse had moved to nearby Fennel Street, but the brewery remained at the Strangeways site, located here to avoid a grain tax imposed by Manchester Grammar School, a strange and much-hated levy where within the town-centre boundary a mandatory rule that grain had to be processed at the school's mill would have increased beer prices.[42] The arrival of the brewery occurs at the start of Manchester's industrial development. Maybe a coincidence, but a very timely one. As we have seen, most pubs were operating as single-publican brewers at this time both

locally and nationally, but the rising population and demand for beer in working-class strongholds provided a business opportunity for brewing on a larger scale. By 1809, the brewery was occupied by Hole & Potter, and by the mid-1820s, John Harrison had joined the company. By the 1830s, Potter had left the brewery and Samuel Hole retired in 1848 to resume his work as a maltster at Caunton in Nottinghamshire.[43] It was during the 1830s that thirty-four-year-old Henry Boddington joined the brewery. The first of the Boddington dynasty, Henry I was born in Thame, Oxfordshire. His father, John, a miller by trade, was forced to move his family north due to the economic depression of the 1830s. Henry began employment initially as a traveller for the brewery and worked his way up to become a full partner. John Harrison continued at the brewery after Hole & Potter left until 1853, when he also left the company and Henry Boddington became sole proprietor, heralding the arrival of the Boddingtons name that has made the company renowned. Boddingtons became a family business, and three of Henry's sons subsequently joined their father in the management of the brewery.

As one of Manchester's older and more established commercial brewers, the company's purchase and loans on public houses began earlier than other breweries in the area. However, this property investment was, in hindsight, ill-timed and the brewery struggled to survive since it coincided with the 1830 Beer Act, which reduced brewery sales in the wake of the competition public houses faced from beerhouses. The 1834 Beer Act, which tightened the 1830 legislation and facilitated the removal of many of the poorer beerhouses, helped the brewery and the rise in productivity alleviated their problems to some extent, but the company suffered from property depreciation for a while.[44] However, there was loyalty and continuous service and one such example is that of the Bowker family who kept the Waggon & Horses at Peel Green, and invoices from the company archive indicate that the family did continuous business with the Strangeways Brewery for around sixty years between 1790 and 1850.[45] Since their early purchases of public-house properties were not financially successful, the company waited until the 1850s to recommence this process, and, by the 1870s, they were making more regular acquisitions. Even then it only amounted to a few properties and from 1874 the company purchased only around three to five houses per year on average.

Henry I began updating the brewery's technology and this took around twenty years to fulfil, but, by the early 1860s, the brewery was firmly established, with beer output reaching 16,427 barrels per annum. A decade later, in 1872, this had risen to 50,627, and, by 1877, five years later, this had more than doubled to 106,506. By 1874, Boddingtons had become Manchester's largest brewery and in around 1880 the company was producing in the region of 112,661 barrels, almost double its nearest rival, Threlfalls of Salford.[46] Ironically, Threlfalls' predecessors, Lupton & Adamthwaite, had both been employed at the Strangeways Brewery around the beginning of the century before forming their own business.[47] Henry and his wife Martha had eight children of which three were sons, Henry II, William, who was a solicitor, and Robert.[48] In 1873, Henry Boddington II, at just twenty-three, joined the company as a partner and was quickly given major day-to-day responsibility and,

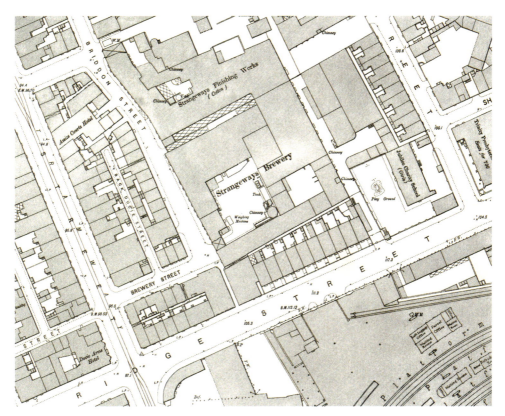

A 1890s map of Strangeways Brewery. (Reproduced with the permission of the National Library of Scotland)

by 1877, Henry I had relinquished most of his role in the business. The Boddington family had great confidence in the company, which is seen with the purchase of the Bridge Brewery in Burton in 1872. This enabled Boddingtons to form a niche in the major brewing area of England and allowed them to adapt the business more easily to changes in beer tastes towards the lighter ales that Burton was so good at producing, and an opportunity Henry I had been keen on pursuing.[49] Despite being a very modest brewery, producing a mere 6,000 barrels per annum against Burton's highest producer, Bass, Ratcliff and Gretton, at well over 800,000 barrels per annum, it placed the company at the heart of the national brewing industry and opened new markets. In 1893, Boddingtons rented out the Bridge Brewery to Everards Ltd of Leicestershire, so Boddingtons' tenure was more short-lived than at first glance. By 1898, Everards had left the brewery owing to its limited capacity. It seemed that Robert Boddington was not so keen on acquisitions to grow the company, and indeed, in 1912, he sold the Bridge Brewery in Burton that Henry I had purchased forty-three years earlier. By this time, technology in brewing had advanced and Burton's water supply was not the main attraction in having a brewery located there.[50]

Boddingtons' brewery ledgers provide a fascinating insight into the company's operations, documenting beer produced by themselves and local competitors, along

with their property book which recorded all properties that came into their ownership.⁵¹ The 1880s was a pivotal time for the company's purchasing of pubs. Only a handful of properties were in central Manchester, with the majority spread throughout the North West in a seemingly random fashion. Most of their pubs were in Salford and Stockport, with many others on the fringes of central Manchester, though their property portfolio stretched from Barrow to Birmingham, and the Bridge Brewery provided business opportunities around the Midlands. Often pubs were purchased following the death of a publican, in part explaining their sporadic geography at a time when there was a scramble for properties in a fiercely competitive business environment. It was also a deliberate policy of Henry I to scatter their acquisitions so they were not too concentrated in one area.⁵² The transaction costs of servicing these pubs with beer must have been much higher than local outlets, but this was part of a national trend of breweries investing in properties at an alarming rate during this later period of the nineteenth century and seemed to be a price worth paying. A further inventory from the 1880s recorded publican-brewers that Boddingtons were targeting for trade. For example, John Trow, a beer retailer in Salford, was recorded as an individual brewer. William Lord of the Dyers' Arms, near Bury, brewed his own mild but bought in Tetley's bitter. Thomas Arrowsmith of the Friendship Inn in Middleton brewed all his own beer, but this was recorded as unsafe to drink. Sarah Hall of Rhodes traded with Wilsons and refused to change suppliers. Sam Haywood in Little Heaton brewed some of his own beer and obtained the rest from Wilsons and J. W. Lees.⁵³ Boddingtons was trying to persuade those publicans who remained independent to either give up their brewing or switch brewers.

Henry Boddington & Co. Ltd was registered in 1883 and was reconstructed as Boddingtons Breweries Ltd in 1887.⁵⁴ By this time, they had acquired around seventy-five properties as well as the Bridge Brewery. The prospectus for the new Boddingtons Breweries Ltd aimed to offer shares beyond those who were members of the brewery and immediate associates. It was during this phase in the brewery's history that the death of Henry I, at his Cumbria home aged seventy-three, was announced in August 1886. His obituary described him as a private, kind-hearted, and generous man and a staunch churchgoer, so it is a fitting tribute to see Henry I commemorated in a stained-glass window in St Ann's Church in central Manchester. The window is part of a scheme from the 1890s designed by the artist Frederic Shields and made by Heaton, Butler & Bayne.⁵⁵

Henry Boddington II was also a pillar of the community in terms of holding civic office. In 1881, he was elected a councillor for Cheetham ward and was returned three times, accumulating a decade's worth of service. He sat on several corporation committees, including the Free Libraries and Art Gallery committees. His other roles included membership of the Building Committee for Manchester's Jubilee Exhibition, a governor of Hulme Hall, and a trustee of the Mynshull Charity, and the list went on. He was also a strong advocate of the Manchester Ship Canal. He was encouraged to seek election for Parliament but decided he was too busy to pursue this ambition! Henry II's brother William continued his role as a solicitor but also became a chairman of the brewery. He also held civic roles and was president of the Manchester Law

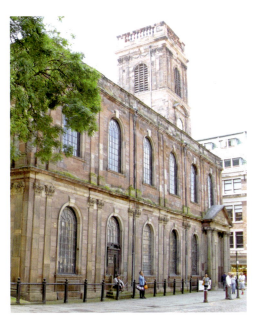

St Ann's Church, central Manchester.

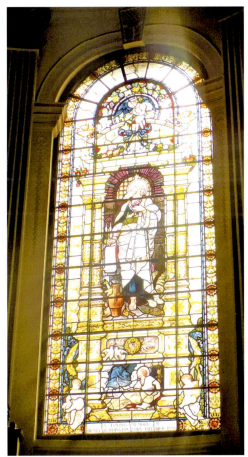

A stained-glass window in St Ann's Church commemorating Henry Boddington.

Association, chairman of the Eccles Division of the Conservative Association, and a prominent member of the Manchester Constitutional Club. He died in July 1908, aged just fifty-five. Robert became a brewery director in 1888, aged just twenty-five, after already working there for nine years, and totted up forty-seven years as a director and forty-two as managing director.

On 1 January 1888, Boddingtons Breweries Ltd began with Henry II as its chair. The same year they acquired the Sandywell Brewery in Salford, along with seventeen licensed houses. In 1900, they purchased Hull's Brewery at Preston, with a further sixty houses, and seven years later the Isle of Man Brewery and thirty-four licensed houses. Henry II's son, Henry III, became a director in 1908.[56] During the following years, trade fluctuated due to the First World War and the interwar Great Depression, with the trade in 1932 proving to be its worst year on record. William became the chair after Henry II stepped down, and Robert continued his role in the company. He had four sons of which two, Philip and Geoffrey, joined the business. Philip went on to become the chair and both he and Geoffrey managed the business together. No sooner had they recovered from the interwar period, the Second World War commenced and in December 1940, as mentioned earlier, the brewery was struck by a bomb. This put the brewery out of action for several months, and their neighbour, Joseph Holt, stepped in to provide beer.

Following the Second World War, Boddingtons took the opportunity to modernise the brewery, embarking on a major construction programme. The Strangeways Brewery was once again expanded and state-of-the-art brewing equipment was installed. Philip Boddington's son, John, and Geoffrey's son, Ewart, joined the brewery. In 1952, Philip died and Geoffrey took charge. They made more acquisitions, and in 1962 purchased Richard Clarke & Co. Ltd of Stockport and in 1971 took control of the last remaining brewery in Hulme, J. G. Swales, along with its thirty-eight pubs and six off-licences, which allowed Boddingtons to increase sales in places such as Wigan and Bolton.[57] The brewery was redeveloped once again in the 1970s and the company flourished in terms of new technology, output, and profits. They purchased Oldham Brewery Ales in 1982 with eighty-seven houses, but this acquisition was on condition that the Oldham site was kept open for five years after the takeover, and indeed the site lasted until 1988. They also acquired Higson's Brewery Ltd of Liverpool in June 1985 with 160 tied houses. By 1986, Boddingtons was still family-owned with over 500 tied houses and employing 280 people, but this came to an end in 1989 when Ewart Boddington sold the brewery and the brand name (but not their tied houses) to Whitbread & Co.[58] They invested in the brewery and not only increased production but provided a larger network of pubs to service. However, they sold off the recently acquired Higson's Brewery.

Boddingtons' sales flourished under Whitbread and reached new national and global markets. In 1995, Greenall Whitley purchased their tied estate of houses. The 'Cream of Manchester' advertising campaign brought the brand a whole new level of attention, which extended into supermarkets, including the 'Bodkan', a large 2-litre can of beer, and the widget, a device fitted into cans to provide the creamy head that

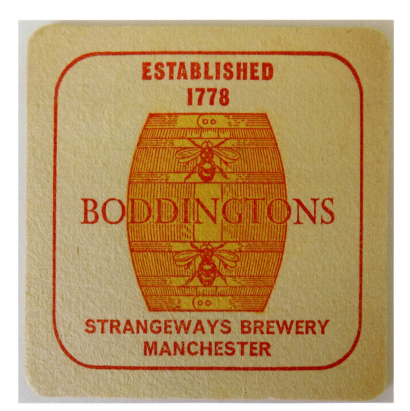

A Boddingtons beer mat that reflects its historic beginnings.

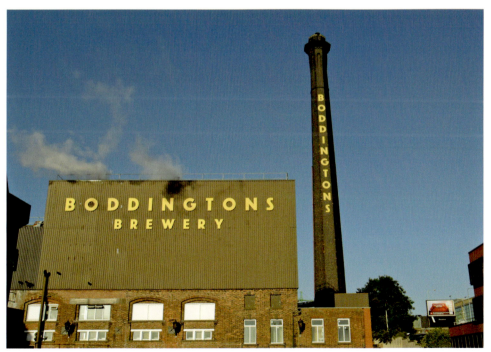

Boddingtons Brewery in the twentieth century. (Courtesy of Alamy)

Boddingtons was renowned for and to emulate a pulled pint that only a proper pub had so far been able to achieve.

The brewing arm of Whitbread was acquired by Interbrew in 2000. The Strangeways Brewery closed in 2005 after a three-year battle by locals to keep it open and which ended 227 years at the site. The name still exists but the beer as it was once produced is not unique to Manchester. The car park that took over the site is a sad reminder of lost heritage, though the post-pandemic era marks a new chapter with the establishment of a further education college there.

Boddingtons advertisements of the 1980s and 1990s conveying a cheeky northern wit.

Boddingtons 'Cream of Manchester' advertising campaign was very effective.

Recent Boddingtons branding has returned to a more traditional image.

4

Ardwick and Hulme

Ardwick and Hulme became key brewing districts of Manchester. Here we take a tour of this part of Manchester's brewery heritage, which again offers some notable names in the industry.

Chesters, Ardwick Brewery

One of the big names that emerged in local brewing was that of Chesters, which was established at the Victoria Brewery in Ardwick by Richard Whittaker, a gum and starch manufacturer who had a nearby factory. The brewery was rented out to Samuel Collins and Thomas Chesters in 1842, and from this point the brewery's history begins in earnest. Samuel Collins was a brewer from Chorlton-on-Medlock and Thomas Chesters was an Ancoats shopkeeper. Collins had already purchased the Dog and Partridge public house, near Ashton-under-Lyne, in 1837 and it is assumed that he took this pub into the business when he joined forces with Chesters.[1]

Their success and limited size of the Victoria Brewery led to Collins and Chesters renting the Mayfield Brewery, close to London Road (now Piccadilly) railway station from Hydes Brewery, and in doing so provided a catalyst for a deep connection between the two companies. Collins and Chesters went on to purchase land and constructed the Ardwick Brewery, which began operation in 1851.

Their public-house acquisitions began in the 1850s, the first being the Green Dragon in Ancoats in 1856 and followed by the Openshaw Inn in 1858. An additional six were acquired during the 1860s. However, during this process, the partnership between Samuel Collins and Thomas Chesters was dissolved in 1853 and the company continued with Thomas Chesters alone.[2] Between 1868 and 1888 the brewery acquired a further seventy-eight houses.[3]

Thomas Chesters died in 1872 and his nephew, Stephen Chesters Thompson, succeeded him in the company. The brewery was closely linked with Manchester City Football Club in its early years, especially through Stephen, who was the club's first president, and this association lasted until 1917.[4] Chesters provided the club's Hyde Road ground and the formation of Ardwick Football Club, as Manchester City was originally known, took place at Chesters' Hyde Road Hotel in 1887.

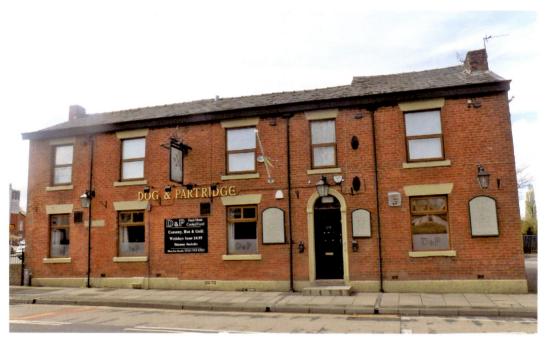

The Dog & Partridge public house, Ashton-under-Lyne.

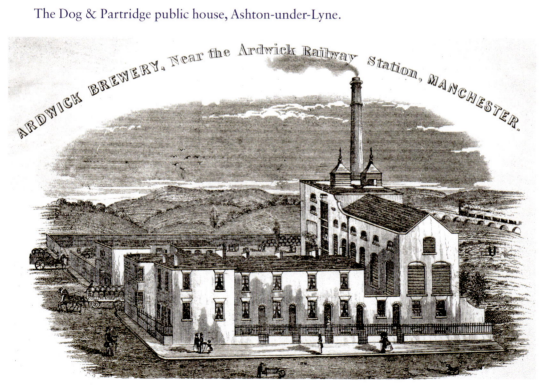

An early impression of the former Ardwick Brewery. (Courtesy of Manchester Local Studies & Archives)

Beer mats that depict Chesters at the Cook Street Brewery and the two northern cities that formed part of its heritage.

During the late 1870s, the company purchased some pubs in the Midlands and a depot in Walsall, where beer was sent by rail from Ardwick, in a break with their localism.[5] They acquired approximately twenty-four properties in the Midlands, in locations in Kidderminster, Staffordshire, and Derbyshire. The executors of Thomas, led by Stephen, ran the business until April 1888 when Chesters Brewery Co. Ltd was registered along with eighty-one licensed houses.[6] In 1894, the link between Hydes and Chesters was strengthened when Charles Frederick Hyde joined the company as head brewer. Charles proved to be an excellent brewer, establishing a reputation for quality beer and brewing innovation. As a qualified chemist, he was continuously experimenting with yeasts, malts, and sugars, taking out his first patent in 1911. In 1920, he introduced a new best mild for Chesters, which proved particularly popular after the poor quality of wartime beer. The brewery was no stranger to mild beer production, but Charles Hyde excelled at the brew and just a year after his arrival they were producing a range of new beers such as Common Mild selling at 42/- a barrel, a Best Mild at 48/-, and a Special Best Mild at 54/-, as well as a Bitter (60/-) and Strong Ale (72/-).[7] Their spell in the Midlands was relatively short-lived and all their acquisitions of the late 1870s had been relinquished by the mid-1890s. Following their departure from the Midlands, they purchased a further thirty-two pubs, this time more locally, which were likely replacements for the ones they had sold off.

In 1888, Chesters acquired John Battersby & Co. of the Wellington Brewery in nearby Openshaw, with around forty-three pubs and other properties, but later the same year leased it out to J. H. Lees.[8] Lees remained at the Wellington Brewery until 1895 when it was closed and he went on to purchase the Moss Side Brewery (formerly known as the Albert Brewery).[9] A further brewery, the Swan Brewery in Ardwick, was also acquired by Chesters in around 1890 through the executors of its previous owner, John Foster. However, it appears that Chesters did not necessarily need a new brewery and, once again, quickly leased out their new acquisition, this time to Simpson and Crummack. In December 1898, the Empress Brewery went on to acquire the Swan Brewery from Henry Crummack, where they remained until the 1920s.[10] Chesters also purchased some smaller breweries that came on the market, including the Old Royal Altrincham Brewery in 1890, managed by George Richardson and Benjamin Goodall, along with around twenty-one pubs, and the Salford Brewery Co. Ltd in 1894 following their liquidation.

During the twentieth century, like other breweries, the compulsory purchase of properties due to slum clearance initially hit the company hard. For example, in 1936, they lost two pubs in Ancoats, the Commercial Inn and Gardeners Arms, and a further property in Ardwick. Despite this, the brewery's expansion into central Lancashire steadied the business and in the ten years from 1935, a further twenty-two houses were obtained.[11] In December 1940, Chesters suffered significant bomb damage with the loss of the Woolsack Hotel in Strangeways and, by June 1941, eleven houses had been damaged in one way or another. We pause the story of Chesters here until it is picked up again as we venture into Salford and look at the history of Threlfalls. In 1961, Threlfalls amalgamated with Chesters and the history of both breweries entwined to form Threlfalls Chesters, one of the region's bigger breweries during the twentieth century.

Yates's Castle Brewery

Originating in Birkenhead on the Wirral in the 1830s, it was over forty years later, in 1877, that the Yates's Castle Brewery in Ardwick was formed by Charles Gatehouse and William Yates, creating a Manchester branch of the business. Their partnership lasted a decade when, in October 1888, Yates bought his partner out and became William Yates Company Ltd, with around forty properties.[12] Yates's Castle Brewery emerged in 1896 and by this time had amassed 175 houses.[13] William Yates died in 1897 and Henry Lycett became chairman.[14] The Birkenhead Brewery lasted until 1934, but the Manchester brewery continued well into the twentieth century until it merged with John Smith's Brewery of Tadcaster, near York, in 1960. By 1966 brewing ceased at the Ardwick site when it was sold to Allied Breweries and used as a depot.

The Cornbrook Brewery

Another notable brewing name that originated in Hulme was the Cornbrook Brewery, an old and established concern that can be traced back to 1791, initially under the ownership of Jonathan Marsh, followed by Edensor & Co. later in the decade.[15] Between 1800 and 1815, the brewery changed hands twice, but by 1820 the brewery ceased production and the buildings had been sold off. From here there is a gap in the record of nearly fifty years and the next we hear of a Cornbrook Brewery is in 1868, this time with a newly built brewery on Ellesmere Street, just across from the original site.[16] Its owner, Samuel Renshaw, formerly of the Swan Brewery, appeared in the press due to bankruptcy and was forced to leave, making way for the O'Neill family to eventually take control.[17] By the 1880s, this included the Weld-Blundell family on the board of directors, and Henry Weld-Blundell was chairman of the brewery until his death in 1901. During the late 1890s, the Cornbrook Brewery began acquiring other breweries and properties, such as R. E. Mottram of Salford, following Mottram's death, and, as has already been seen, the Lancashire properties of Boardman's United Breweries Ltd. The brewery continued to grow into the twentieth century, acquiring the Heywood-based Phoenix Brewery which came with around 120 properties. The brewery was badly damaged in the bombing raids of 1940 and had to be rebuilt, with brewing not recommencing until spring 1941.[18] By the 1950s, the Cornbrook Brewery

YATES'S CASTLE BREWERY LIMITED
SUBSIDIARY OF JOHN SMITH'S TADCASTER BREWERY COMPANY LTD.

CASTLE BREWERY, ARDWICK, MANCHESTER 12. *Tel.* ARDwick 2666/7
Also at Birkenhead

Yates's Castle Brewery letterhead illustrating their castle trademark. (Courtesy of the Brewery History Society)

had forged strong links with the brewing giants of Wilsons and Inde Coope and, by the early 1960s, had become part of the large conglomerate of breweries known first as Northern Breweries then later United Breweries Ltd. This was subsequently acquired by Bass Charrington and the Cornbrook Brewery ceased production in 1973. Bass House was built on the site of the old brewery and became the headquarters for Bass Taverns in the late 1980s.[19]

Hardys Crown Brewery

Dating from the later 1840s, Hardys Crown Brewery was originally owned by William Roberts, who had a long career at the brewery until his death in 1888, aged eighty-three. Roberts became wealthy, moving from the humble surroundings of Hulme to the richer suburbs of Didsbury in south Manchester. He was a generous man who gave much to his local community, including funds for the construction of Christ Church in Withington at a cost of around £18,000.[20] The brewery subsequently became Hardys Crown Brewery Ltd in 1889 which lasted until 1962, when it was taken over by Bradford-based Hammond's United Breweries and subsequently formed part of United Breweries, which, like the Cornbrook Brewery, was subsumed by Bass Charrington. The Crown Brewery had around seventy-three tied houses at one time or another and one of these included the Salutation public house, which is currently owned by Manchester Metropolitan University and still retains its original Hardys Crown Ales signage.[21]

A beer mat featuring Hardys Crown Brewery branding.

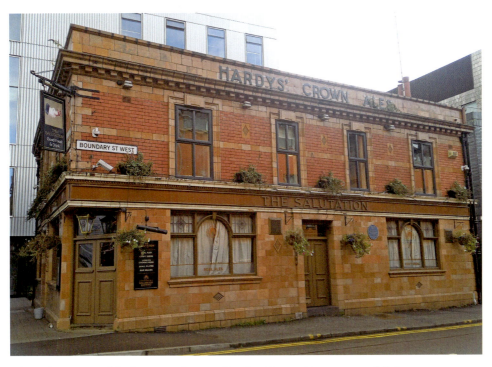

The Salutation public house, a former Hardys Crown Brewery establishment.

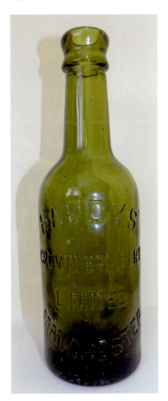

A Hardys Crown Brewery beer bottle.

James Kay, Atlas Brewery

The Atlas Brewery, once located in Ardwick's Stockport Road, appeared at the end of the 1860s and was initially owned by the wine merchants and brewers Hannay & Dickson. They remained there until the early 1880s, when James Kay came into possession of the business. In 1896, Kay joined forces with the Standard Brewery and together they had 125 tied houses and twenty-five other properties.[22] The Standard Brewery originated in around 1816 and was located close to Oxford Road, in Jenkinson Street, where the current Manchester Metropolitan University campus is today, and was originally known as the Chorlton-on-Medlock Brewery. By 1841, Thomas Bake was recorded there.[23] Thomas was also the publican of the Crown & Anchor, on Port Street in central Manchester, for a time but faced financial difficulties and was declared bankrupt in 1844, and unfortunately died just a couple of years later aged just forty-three.[24] His son, also named Thomas, continued at the brewery until around 1858 when John Taylor took control for three years, followed by Beaumont & Heathcote from 1861. Beaumont & Heathcote had formed in nearby Maskell Street, also in Chorlton-on-Medlock, before moving to the Jenkinson Street site, and they renamed it the Standard Brewery. In 1896, they formed a collaboration with James Kay's Atlas Brewery, a partnership that lasted around thirty years until 1929 when the company was acquired by Stockport's Frederic Robinson.[25]

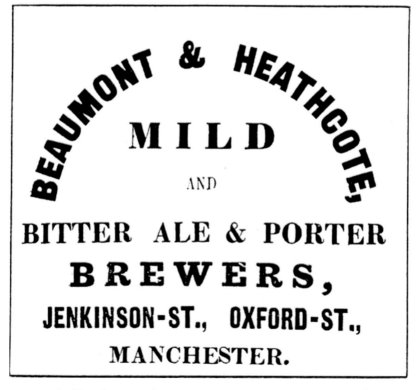

A Beaumont & Heathcote advertisement, *c.* 1863. (Courtesy of the Brewery History Society)

The Openshaw Brewery

North of Ardwick was the district of Openshaw, home to the Openshaw Brewery Ltd. It had begun with a partnership of Wagster & Goodrick, which was dissolved in 1861 and Wagster took sole ownership.[26] He died in 1874 and the brewery was administered under his executors for almost ten years until 1883, when Richard Wright took control and it became the Openshaw Bridge Brewery Ltd.[27] By 1890, the company had moved to the Victoria Brewery in nearby Gorton and later in the decade, in 1897, the brewery was re-formed, and had grown to include thirty-one pubs and over 100 beerhouses and shops. The rest of the brewery's history is similar to that of others in the area. It was acquired by Sheffield-based Hope & Anchor Breweries Ltd in 1957, soon followed by Bass Charrington in the 1960s. Brewing ceased at the site soon after the takeover by Hope & Anchor and the buildings were demolished in 1964.[28]

5

Around South Manchester

Hydes, Queen's Brewery

After over 160 years in the Manchester region, Hydes remains a successful and independent brewer. The brewery, which moved from Moss Side to Salford Quays in 2012, began in around 1860 when Thomas Shaw took on the Crown Brewery in Audenshaw, a small town between Ashton-under-Lyne and Manchester. Little is known of the brewery before Thomas acquired it, but it is believed to have existed for a while before his arrival. The Crown Brewery traded with pubs around Audenshaw, Ashton-under-Lyne, and areas as far as Glossop on the edge of the Peak District.[1] In 1863, Thomas died and the brewery was passed down to his grandchildren, Alfred and Ralph, children of his daughter, Hannah, and her husband, William Hyde.

Hydes rented the Mayfield Brewery in Ardwick from Thomas Chesters in the early 1870s, partly because the poor water supply at Audenshaw was affecting the quality and consistency of its beer.[2] The brewery was let out by Thomas Chesters. William Greatorex, the former brewer at the Mayfield Brewery, left in around 1867 following his bankrupty and it was a rather protracted transition of about a year before Hydes finally made the move from the Crown to the Mayfield Brewery. This marked the beginning of a long-standing relationship between the Chesters and the Hydes.[3] Their customer base at the Mayfield Brewery was very different to what they had achieved in Audenshaw since most of the pubs they originally serviced did not continue their custom. The company built new trade that covered a wider territory extending to Saddleworth, Bolton, Macclesfield, as well as many central Manchester pubs.[4] Alfred Hyde died in 1880, and his eldest child, Annie, took control of the business. During the latter part of the 1870s, there had been a drop in production, and it is thought that Alfred may have suffered ill health for some time before his death at just forty-four. Following his untimely passing, the company had to be supported out of financial difficulties. Ironically, their financial situation did not deter them from purchasing properties with their first acquisition being the Hare & Hounds at Abbey Hey, near Gorton, in 1877.[5] Annie Hyde, who went on to become a pivotal figure in the company, wrote of the time around 1880 and the year of her father's death. She commented that

'it soon became evidence that if the firm were to exist and continue, the acquisition of licensed properties by purchase must begin', in line with the strategy that most brewers were taking.[6] Given the financial struggles the company faced, it is no surprise that the pub was subsequently repossessed and sold to Boddingtons. In 1882, Hydes moved from the Mayfield site to the Fairfield Street Brewery, which was sold by the executors of Thomas Chesters. This relocation reduced the company's outgoings, and while helping initially, there were still financial struggles. They were at the Fairfield Brewery until 1889 when they relocated again, this time to the Rusholme Brewery to increase production capacity. Their final move for the nineteenth century was in 1899, this time to their longer-term home at the Queen's Brewery in Moss Side. By 1880, their ledgers recorded the ales they were producing, including X Ale, XP, Old Ale, XX Ale, XXP, XXX Ale, BB, SX, and SXX. X Ale became their mild in 1914. By 1924, they were offering three draught stouts, one of which was called XXP.[7]

It was the move to the Queen's Brewery that marked a stable and prosperous time for the brewery. Annie Hyde was instrumental in their survival and success until her death in 1936 after fifty-six years of service. Her brother, William, who had inherited the company alongside her, had died in 1916 and he was succeeded by their brother, Thomas. William had held public office, becoming a Justice of the Peace for central Manchester. The anvil part of the brewery's brand was formalised in 1895 when their famous trademark was registered, and this symbolised the growing and increasingly successful company.[8] They consolidated their position in Manchester's brewing industry during the first half of the twentieth century with the company being

A bottle stopper denoting the Hydes anvil trademark.

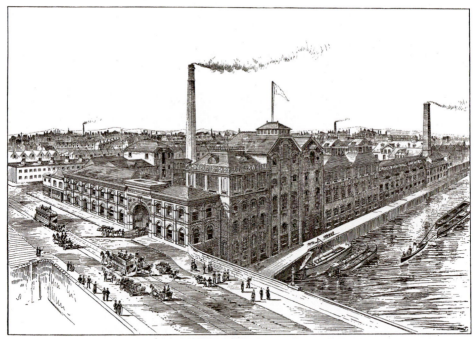

An early sketch of Hydes Queen's Brewery. (Courtesy of Manchester Local Studies & Archives)

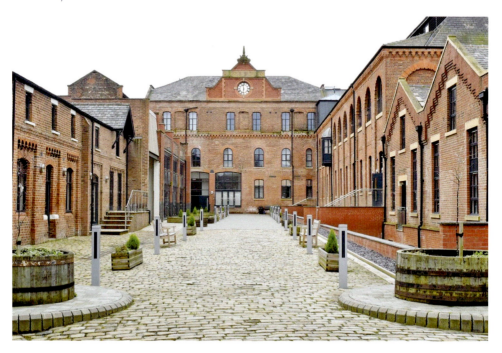

The former Queen's Brewery in modern times. The buildings having been converted into apartments. (Courtesy of Alamy)

registered as Hydes Queen's Brewery Ltd in December 1912.[9] By 1920, Hydes had acquired around thirty pubs.

Annie's death was soon followed by the death of Thomas, who passed away in 1939. By 1940, the brewery had obtained a further five pubs but seemed more interested in the purchase of off-licences and at one time owned around sixty-five shops.[10] The Queen's Brewery was affected by the Christmas Blitz of 1940 and raids narrowly missed the brewery buildings. Despite getting through the war relatively unscathed, it was the post-war redevelopment of Manchester that had an impact on the company with many pubs lost to compulsory purchase orders and even the brewery itself in jeopardy, although thankfully this was averted.[11] The company changed its name in 1944 from Hydes Queen's Brewery to Hydes Brewery Ltd, incorporating its famous anvil symbol into the company's name.[12]

A twentieth-century Hydes anvil beer mat.

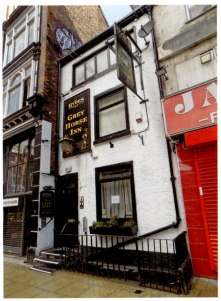

The Grey Horse Inn, one of Hydes' central Manchester public houses.

Hydes Brewery in modern times, located in Salford.

The company remains successful. It is still controlled by the Hyde family, and in 2012 the brewery moved to the Beer Studio, near MediaCity in Salford, where they continue to brew. Their beer reflects the heritage of the company with one named 1863 Chestnut Session Ale and one that reflects their recent move to MediaCity, Lowry Premium Golden Ale, in tribute to the famous local artist L. S. Lowry.

The Moss Side Brewery

Originally known as the Albert Brewery, the Moss Side Brewery was built around 1875 by William Brooks. Following Brooks' death, the brewery was taken on by John Henry Lees in 1894. Lees was originally from nearby Denton, and his family were well known for their quality ales. He purchased the Wellington Brewery in Openshaw from Chesters in the late 1880s to increase capacity and the brewery grew, becoming John Henry Lees Ltd in 1897.[13] It was accorded the title Royal Moss Side Brewery in 1907, following a visit by King Edward VII.[14] However, it was evident in the early part of the twentieth century that the brewery was facing financial difficulties, partly due to legislation that was detrimentally affecting brewers and pubs. In 1913, the brewery went into liquidation and was acquired by the local brewer Walker & Homfrays Ltd. It ventured into lager production in the late 1920s, producing the UK's first lager, Red Tower, and, in 1933, took the name of this to form Red Tower Lager Brewery. However, by 1955, it had returned to its former name, the Royal Moss Side Brewery. In recent times, it has had several ownerships, including Scottish Brewers to produce McEwan lager, Harp, and more recently Heineken, which took control in 2008. It is now known as the Royal Brewery and remains modern and highly productive.[15]

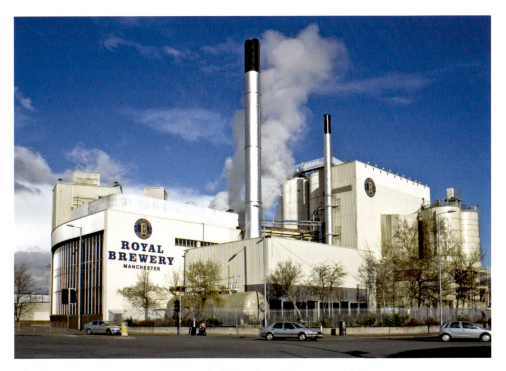

The former Royal Brewery, currently Heineken. (Courtesy of Alamy)

The Empress Brewery

The building that housed the Empress Brewery still exists as a business centre and is a reminder of its fascinating heritage. It was started by Charles Dewes, who began brewing in Hulme during the mid-1860s. At around the same time, William Henry Fulford began brewing in nearby Ardwick.

By 1877, Fulford had joined forces with Robert Gill at the Horseshoe Brewery in Salford, but just three years later the brewery went bankrupt and the pair parted company. William moved to the Monarch Brewery in Salford and continued with his other occupation as the publican of the Nag's Head in central Manchester.[16] In 1883, William acquired the business of Charles Dewes and the brewery became W. H. Fulford & Co. A new business known as the Empress Brewery Company was formed in 1896, and this incorporated another nearby concern, that of the Old Trafford Brewery Company.[17] Two years later, they purchased the Greatorex Brothers at the Queen's Brewery and Swan & Crummack's Swan Brewery, and, as we have seen, the Queen's Brewery was sold to Hydes. Fulford and Crummack became directors of the Empress Brewery, but in 1899 the pair became entangled in a litigation battle through the courts when Fulford took out a libel case against Crummack, who had made allegations of misconduct. In 1901, Fulford won the case and was awarded £500 in damages but relations among the directors were badly damaged, and he finally resigned from the board in 1906.[18] There had been rumours of a merger with Wilsons, but the Empress Brewery was taken over at the end of 1928 by Peter Walker & Sons (that eventually became Walker Cain Ltd) of Warrington and brewing ceased at the site.[19]

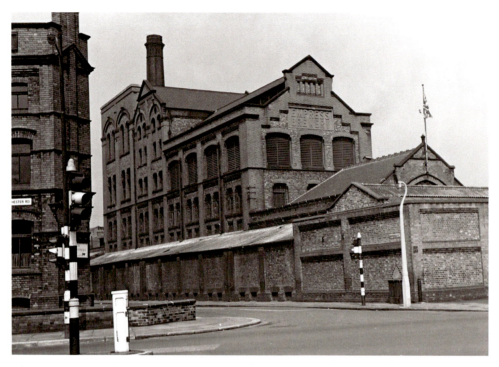

The Empress Brewery in the 1960s. (Courtesy of Manchester Local Studies & Archives)

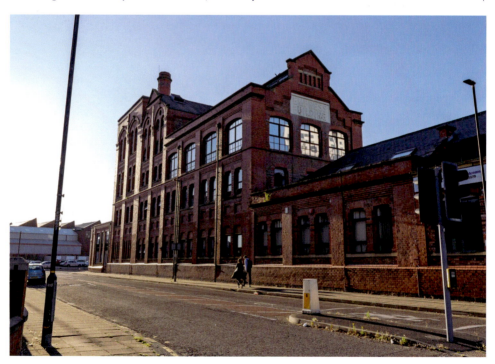

The Empress Brewery building in modern times, having been converted into a business centre. (Courtesy of Alamy)

Frederic Robinson, Unicorn Brewery

Located in nearby Stockport, Robinsons has had important connections with the pub trade in central Manchester for many years. Up until recently, it was based in the town's Lower Hillgate, where its origins can be traced back to the 1830s when William Robinson purchased the Unicorn Inn.

Robinson, a corn and flour dealer, originated from Macclesfield in Cheshire. His younger son, Frederic, joined the business in 1878, and at the time the company owned two public houses. Frederic had an eye for business, and he saw the potential for increasing his income by meeting the growing demand for beer. By the time of Frederic's death in 1890, they had acquired twelve pubs and the brewery was operated by his executors until 1920, when it was registered as Frederic Robinson Ltd, by Frederic's widow, Emma, along with William Robinson and his sons, Frederick, John, and Cecil. The company made several brewery purchases in the area, such as Schofield's Portland Brewery in nearby Ashton-under-Lyne along with forty-two tied public houses in 1926. Three years later, they acquired Manchester's Kay's Atlas Brewery along with eighty-six licensed houses, which put Robinsons at the heart of the Manchester beer market. William Robinson died in 1933 after devoting fifty-five years to the brewery. He was succeeded by his son, John, whose three sons eventually joined him in the company during the 1950s and 1960s. The company remained profitable during the earlier part of the twentieth century, despite the difficult economic climate of the 1930s and the wartime era. When other brewers focussed on purchasing local urban pubs, John Robinson bought pubs in country areas, including rural Cheshire and the Derbyshire Peak District, and this could explain the company's stability as they were not impacted by the slum clearance programme that affected many local brewers.[20]

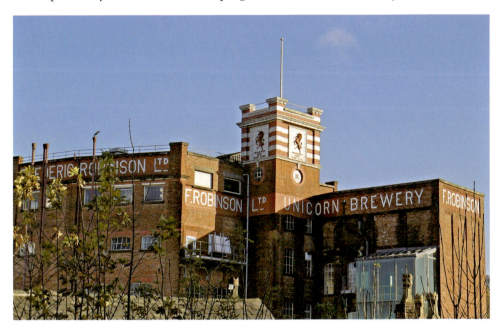

Robinsons at the Unicorn Brewery, Stockport. (Courtesy of Mike Serigrapher, Flickr)

A bottle top and beer-pump label that depicts the Robinsons brand image of the unicorn and its origins in 1838.

The Castle public house, central Manchester, a former Robinsons establishment.

In 1949, Robinsons purchased the Stockport-based Bell & Co. Ltd of the Hempshaw Brook Brewery with its 160 licensed houses.

In recent decades, Robinsons have moved in a radically new direction. It added keg beer to its draught portfolio and increased bottled beer production. In 1976, the company built a new packaging centre at nearby Bredbury, which proved to be one of the biggest initiatives ever undertaken by the family. Sir John Robinson died in 1978, fittingly at his desk in the brewery. He had been their chairman for forty-five years and he bequeathed to his family a business that was in a strong and competitive position.[21] In 1982, they went on to purchase the Ulverson-based Hartley's at the Old Brewery together with fifty-six tied houses.

Robinsons have developed a reputation for their uniquely named beers. These include Trooper, a beer made in tribute to the heavy metal rock group Iron Maiden that is a popular brew among the band's followers. It was an unlikely but successful collaboration of a family brewer and rock stars. Initially, the Bury-based rock band Elbow, who were visitors to one of Robinsons former city centre pubs, the Castle on Oldham Street, asked if a beer could be made for them. This in turn led to the management team of Iron Maiden also contacting the brewery with a beer request. The demand was unprecedented and put Robinsons on the global map. Tours of the Robinsons Brewery became a mecca for Iron Maiden fans everywhere. The logo for the beer, depicting a snarling, skull-like figure brandishing a Union flag, is a far cry from the brewery's gentler heritage.

In 2012, the family installed a new brewhouse at a cost of £6 million to create much-increased capacity. The success of Trooper in 2013 soon led to the new capacity being maximised. Trooper is still one of the most popular beers followed by its Unicorn Bitter and Dizzy Blonde. The latter was initially the subject of controversy for depicting a female in skimpy clothing but the beer's image now features a female face on an aeroplane fuselage in the style of American fighter planes in the Second World War. The success of Trooper has seen export sales quadruple, with Unicorn and the legendary strong ale Old Tom (which has been in production for over 100 years) available in foreign markets. The strength of family control is undiminished. The company remains with the Robinson family and in 2022, the company announced plans to relocate the central Stockport brewery to nearby Bredbury, ending not far off 200 years at their original site.

Beer-pump labels illustrating their iconic Trooper and Dizzy Blonde beers.

6

Salford

William Joule & Sons

We begin Salford's brewery history with one of the earliest in the locality, that of the Joule family brewery. It began with William Joule in the 1780s on New Bailey Street, on the Salford–Manchester border, and at the time located close to the notorious New Bailey prison. William and his brother, Francis, originated from Derbyshire, and both entered the brewing industry, with William coming to Salford and Francis heading off to Staffordshire.[1] It was a family concern and William's sons, Benjamin and Henry, eventually joined him in the business. At the time William oversaw the brewery, the staff included Hugh Joule, who was William's clerk and is likely to have been his nephew. William died in May 1799 and the brewery continued under the management of Benjamin and Henry. Another branch of the Joule family via another William and a James ran a brewery for a time at Ardwick Bridge, which they acquired in the early 1820s. By 1834, it was just in the name of James, who became bankrupt in 1837 and consequently the brewery was put up for sale. The brewery that was operated by Benjamin proved to be more successful.

Benjamin's son, James Prescott Joule, became famous for an entirely different reason. Born in 1818, James embarked on a scientific career and became known as one of our most eminent physicists and mathematicians of his day. James appears to have had a modest role in the brewery for a time and unsurprisingly showed particular interest in the scientific and commercial aspects of the business. When Benjamin retired, James chose to sell the brewery, which was auctioned off in 1855 to Thomas and Richard Smith who continued brewing until the mid-1860s. James lived for a while in what is now Joule House in Acton Square, just off the Crescent in what is part of the University of Salford campus.[2] He is remembered with a marble statue in Manchester Town Hall, alongside other eminent figures such as fellow local scientist John Dalton.

Of the original brothers, Francis' son, John, took control of the Staffordshire-based brewery that this side of the family had developed in 1813. He continued in this role for a worthy forty-five years until his death in 1858. He was followed by his son, John Smith Joule, who along with his brother-in-law remained at the brewery until 1873

Joule House, the former home of James Prescott Joule, currently part of the University of Salford campus.

when it was sold. One might have assumed that this was the end of the Joule name in the Midlands. Thankfully not! The brewery retained the Joule name for around a century after John Smith Joule. However, it was acquired by Bass Charrington in the early 1970s in what was an acrimonious acquisition that sparked local discontent and the end of Joule's Stone-based brewery. Despite the original Joule brewery not surviving, in 2010, the Joule name was revived as an independent brand once more, this time in nearby Market Drayton. So, the brewery in Staffordshire that Francis began is still effectively in operation, though not exactly in its original form.[3]

Threlfalls & Co. Ltd, Cook Street Brewery

Threlfalls, originally a Liverpool company, opened a branch in Cook Street on the Salford–Manchester border. Threlfalls were initially recorded in the local trade directory as Bullen, Threlfall & Co. until around 1825 when Thomas Threlfall appeared as the sole brewer on Crosbie Street in Liverpool. John Mayor Threlfall succeeded his uncle, Thomas, and took on the business in around 1830, coming to Salford in the early 1840s to occupy the Greengate Brewery in an expansion of the business.[4] Parallel to this, Lupton and Adamthwaite had operated a brewery in nearby Cook Street from around 1815, and John Mayor Threlfall purchased the Cook Street site from them in 1861.

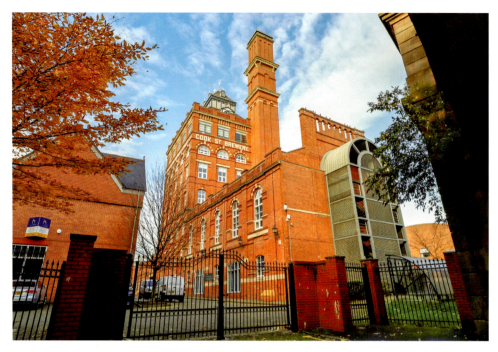

The former Threlfalls Chesters Brewery on Cook Street. (Courtesy of Steven Robertson, Flickr)

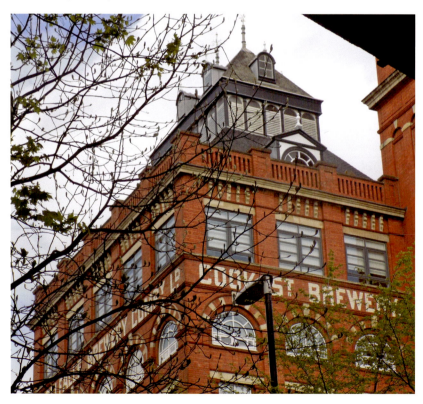

The former Threlfalls Chesters Brewery tower.

Sadly, Threlfall died soon after, in June 1862, leaving a legacy of both the Greengate and Cook Street breweries, in addition to the Liverpool brewery on Trueman Street and the London-based Castle Brewery.[5] In 1865, the Greengate Brewery was acquired by Salford Corporation to redevelop the land with more modern buildings, so this is where the story of Threlfalls ends at the Greengate site, although the Cook Street Brewery flourished. John's eldest son, Thomas, became chairman of the brewery in 1862, alongside John Satchell Hopkins and managers Thomas and George Barker.[6] Thomas was Cambridge educated and commenced a career in law before entering the brewing trade and also unsuccessfully tried his hand at a political career, standing as a Liberal in Lincolnshire in 1885.[7] In 1888, Threlfalls became a limited company, which incorporated both the business developed by John Mayor Threlfall and the amalgamation with the Liverpool brewer W. A. Matheson.[8]

Into the twentieth century, Thomas died in 1907 at his home in Hyde Park Terrace, London, aged sixty-four and Charles Threlfall became chairman.[9] This marked a time for the acquisition of several local breweries, including Handley's Brewers Ltd based at Hulme's Clarence Brewery in 1912 and George Bentley of Ardwick a year later. The Clarence Brewery originated in the mid-1870s with Charles Dewes and had several owners in its life, including W. H. Fulford, Carringtons, and the Manchester Brewery Company. It remained empty for a while, until around 1904 when Handley's Brewery moved in, and they lasted until Threlfalls took over in 1912. Their acquisition of George Bentley's Brewery in 1913 was a relatively short-lived affair having rid themselves of the company by 1916.[10] George Bentley began his career at the Viaduct Brewery during the early 1870s. He died in 1905 and his obituary revealed him to be

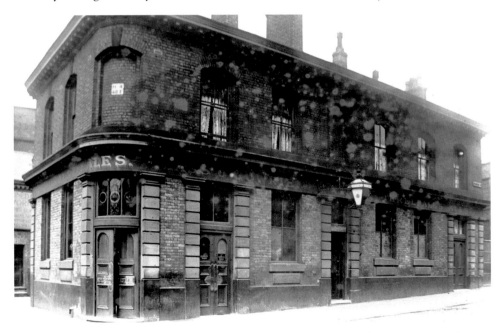

An early photograph of the Lass o' Gowrie public house, central Manchester, a former Threlfalls establishment. (Courtesy of manchesterpostcards.com)

a talented musician as a principal violinist to the Hallé Orchestra and a member of the Manchester Arts Club.[11]

It is here that we return to the history of Chesters Brewery at the point they merged with Threlfalls in 1961, incorporating the Cook Street Brewery, Threlfalls of Liverpool, and Chesters Ardwick Brewery, with a combined total of over 900 tied pub properties.[12] The new company acquired Dutton Blackburn Brewery in 1964 (which had in turn taken on four breweries between 1938 and 1959). The Ardwick Brewery ceased production in 1966 and transferred its operation to Cook Street, which continued production until 1988. However, their tenure was relatively short-lived, since Threlfalls Chesters were themselves taken over by Whitbread in 1967 and here marks the end of two big brewing names in the locality. The Cook Street building that was once the brewery, dating from 1896, remains a fine example of architecture and a prominent landmark in the area today. After a period of neglect, it is now Grade II listed and has been converted into a business centre known as the Deva Centre, containing a mix of offices and businesses with a revitalised new usage.

So, what was the beer like? Well pretty intense if legends were to go by! 'There was nothing meek about Chesters Fighting Mild, as it was known. It sent drinkers staggering out into the streets in search of a scrap, their fists flailing at thin air before they hit the pavement.'[13] Whitbread certainly used this tough image when it took over the brewery.

Above left and right: Threlfalls beer mats. (Courtesy of the Brewery History Society)

A more recent Threlfalls beer mat.

Groves & Whitnall, Regent Road Brewery

Based at the Regent Road Brewery, Groves & Whitnall was the largest brewer in Salford and one of the most notable brewers in the region. Its history, from its origins in the 1830s until its takeover by the Warrington-based brewer Greenall Whitley & Co. in 1961, was firmly rooted in its locality, the Groves family being well established in Salford's community. The brewery ceased production in 1972, with a legacy of over 140 years of beer production.

We know a good deal about the brewery through two key publications. First, it was one of the breweries that were included in Alfred Barnard's epic work *The Noted Breweries of Great Britain & Ireland*; and second, James and Keith Groves wrote a history of the brewery in 1949. The origins of the brewery can be traced from 1835 when Samuel Lyth, who had been brewing at premises on Salford's Chapel Street, began a brewery on Regent Road.[14] Samuel died in April 1843, and his wife Margaret took control of the business. She remained there until around 1850 when, for a brief period, sons James and Thomas took over until 1853, when they sold the brewery to Bathe & Newbold.[15] It is through this partnership that the Groves family came to prominence, initially through William Peer Grimble Groves, who originated from the Walthamstow area of London. He had moved north and initially managed a vinegar works in Hulme but began his brewing career with Bathe & Newbold as a traveller, working his way up to become a manager by 1859. The records for nearby Boddingtons reveal that from the early 1860s, Bathe & Newbold was a prolific producer and even ahead of themselves and Joseph Holt at the time.[16]

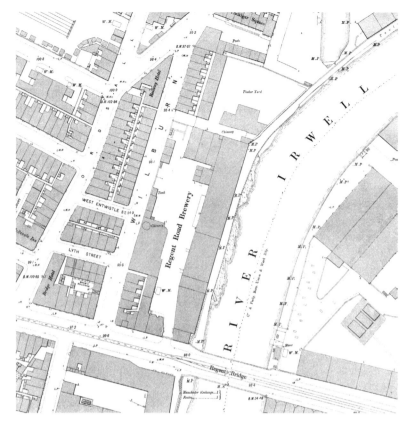

An 1890s map of Regent Road Brewery, Salford. (Reproduced with the permission of the National Library of Scotland)

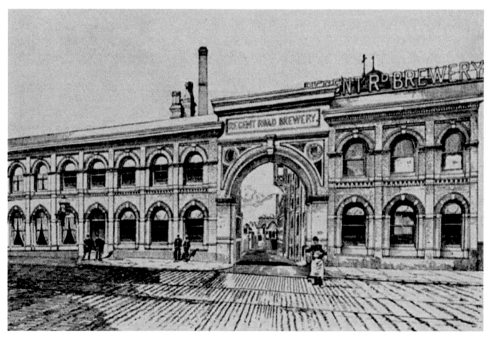

The original Regent Road Brewery. (Courtesy of Anthony Groves)

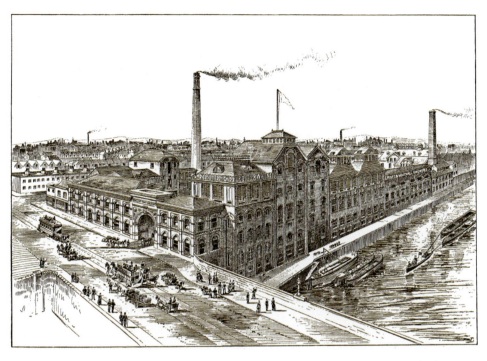

Above and below: Early sketches of the Regent Road Brewery. (Courtesy of Alamy)

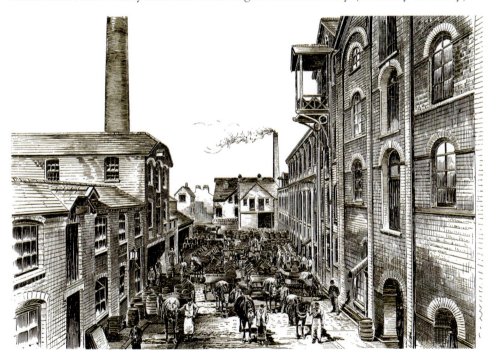

William Peer Grimble Groves.
(Courtesy of Anthony Groves)

William Peer's first son, William Grimble Groves, joined the company in 1864. While studying chemistry at Owens College (the modern-day University of Manchester) he met Arthur William Whitnall. They struck up a solid friendship and after graduating they began a partnership as manufacturing chemists. By 1868, Bathe & Newbold had retired and the business was continued by the Groves family, which also included Arthur Whitnall. Over time other sons, Charles and James, also worked for the business. The brewery was rebuilt in 1882 and at the time of William Peer Grimble Groves' death in 1885, the company owned five pubs, forty-three beerhouses and various plots of land and property.[17] It is around this time that Groves & Whitnall ventured into the relatively recent innovation of bottled beer. This process initially came via Charles Leigh at Leigh & Co., who were providing both a beer bottling and mineral water service for the brewery's pubs. Charles was a member of their board of directors and this partnership was fruitful. Arthur Whitnall, who went on to become William Peer's son-in-law through marriage to daughter Eliza, had obtained the services of Charles Henry Hill, a highly respected and talented brewer from Beaumont & Heathcote of Ardwick. In 1899, Hill became a director but was only there for a year before his untimely death. Arthur Whitnall died in 1890, leaving the younger William and James, the third son of William Peer, to continue the business. By this time, the company had grown quickly with seventy-four freehold and thirty-two leasehold properties.

By the end of the 1890s, the brewery was floated on the stock exchange, and they acquired Hulme-based Alexandra Brewery in 1899, following James Cronshaw's death. William Cronshaw became a brewery director and production was relocated to

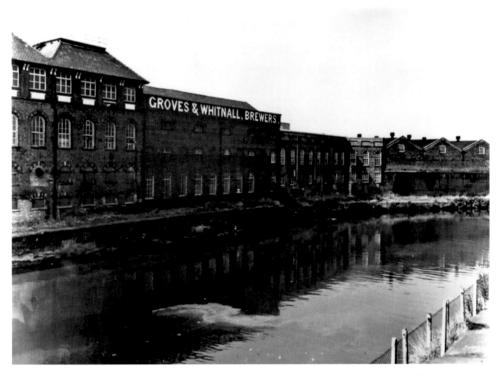

The Regent Road Brewery in the twentieth century. (Courtesy of Salford Archives & Local Studies Library)

Regent Road.[18] The same year, they purchased the tied estate and business connections of the Chorlton Road Brewery. As Barnard concluded, 'for there are not half a dozen in the kingdom whose growth has been so rapid'.[19]

The Groves family became heavily involved in their local community. William Grimble Groves had several worthy and important roles in addition to running the brewery. He was a Salford councillor between 1883 and 1895; Justice of Peace Salford, 1892–1910; and a councillor from 1921 and Justice of Peace County of Westmorland between 1896 and 1927. During this time, he founded the Edith Cavell Home of Rest for Nurses in Windermere in 1920. James Grimble Groves was also prominent in local politics. He was on Salford Town Council and was tipped to be mayor at one stage. He was also a member of the Salford Board of Guardians and Honorary Secretary to the South Salford Conservative Association.[20] He became chairman of the Salford Conservative Association and ultimately the Tory parliamentary candidate for Salford South in the 1900 general election, winning the seat only to lose it to the Liberals in 1906. He was also mayor of Altrincham for a brief spell. The most enduring legacy of Groves & Whitnall, however, is the Salford's Lads Club. Still thriving today, the club was set up in 1903 by William and James Grimble Groves to provide recreation and education. Over 120 years later it remains a focal point for local youngsters and is internationally renowned. Located on the site of a former infantry barracks in Coronation Street, just off Regent Road, the Groves family remain at the heart of its operations.

William Grimble Groves. (Courtesy of Anthony Groves)

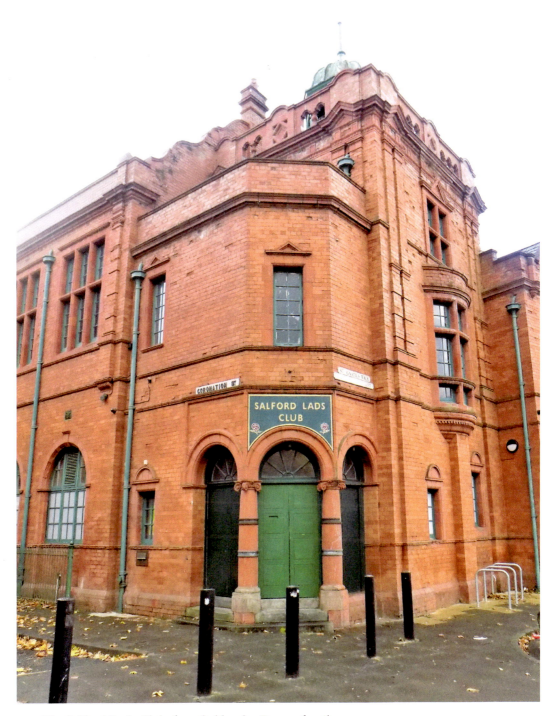

The Salford Lads Club, founded by the Groves family.

The twentieth century proved to be difficult for the company. First, there was the 1901 poisoning scandal that will be discussed later but had a particularly detrimental effect on the brewery's reputation. Neither did they escape wartime destruction, and the brewery was severely damaged in the Christmas Blitz of 1940. The old part of the brewery was decimated but the newer part survived. The caretaker, Mrs Bentley, who lived onsite, and a member of the firefighting team were killed.[21]

The final nail in the coffin came when Groves & Whitnall were subject to a takeover by Greenall Whitley of Warrington in 1961, which marked the beginning of the end for the Regent Road brewery. It finally ceased production in 1972 and another of the region's big brewers became subsumed in yet another takeover.

So, what about their beer? Barnard commented:

We noticed particularly that of their well-known C brand which impressed us as being a mellow-flavoured ale with a fine distinctive hop character. We also sampled the 'Crown stout' as the most nutritious beverage which would compare favourably with any we have sampled in London.[22]

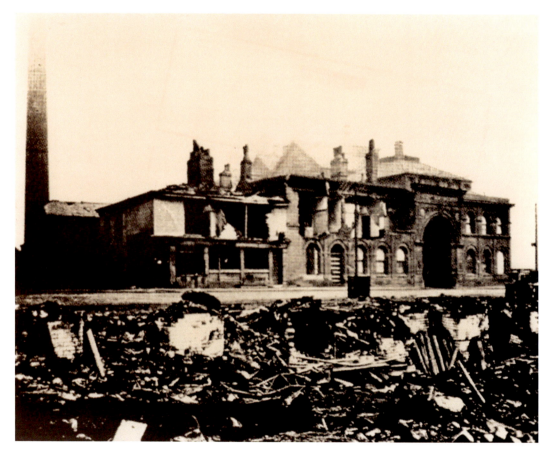

The Regent Road Brewery was badly damaged in the Christmas Blitz of 1940. (Courtesy of Salford Archives & Local Studies Library)

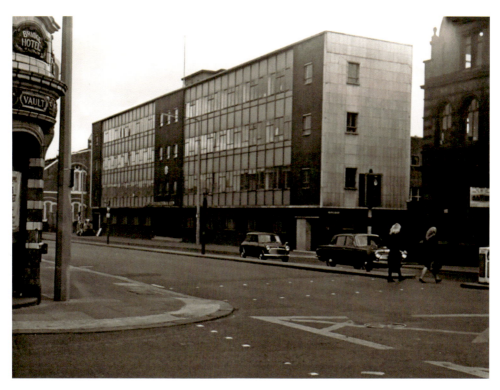

The Regent Road Brewery, *c.* 1970. (Courtesy of Salford Archives & Local Studies Library)

A Groves & Whitnall beer mat featuring their red rose trademark.

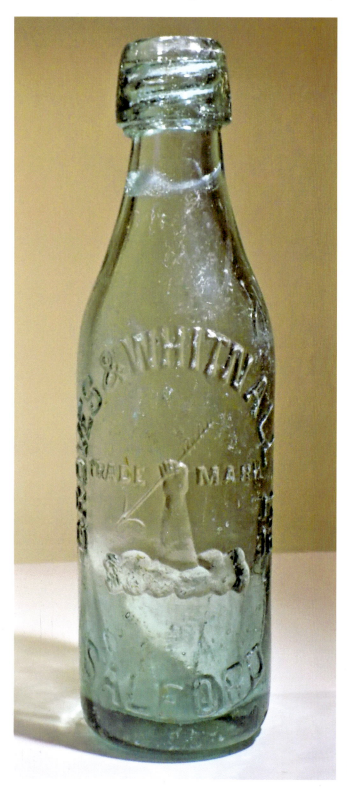

An early Groves & Whitnall beer bottle.

7

Twentieth Century and Beyond

Having surveyed the key brewers of Manchester and Salford, it is apparent how many famous names disappeared with brewery takeovers. However, as we head into the twentieth century, we learn of other factors that shaped the industry, including the arsenic poisoning scandal that shook the industry at the turn of the century. By looking at specific brewery histories it is clear how many were affected by slum clearance and post-war reconstruction, resulting in many pubs being lost. We examine the areas that were affected and the politics behind slum-clearance decision-making. It is apparent how the pub has declined and here we examine societal changes that have contributed to this. Finally, we look to a brighter future for brewing with the rise of microbreweries and a return to small-scale brewing and local production. Have we come full circle in the story of the local brewing industry? Let's find out.

The 1901 Beer Arsenic Poisoning Scandal

The turn of the twentieth century in Manchester proved to be a bad time to drink beer! It was not due to the likely reasons such as drunkenness, cost, or lack of pubs, but a scandal that witnessed ordinary working-class people, who were often criticised for drunkenness, inflicted with a condition that itself mirrored drunkenness, that of arsenic poisoning. The poorer end of society was accused of excessive drinking when in fact it was contaminated beer killing and causing severe illness, and only a handful of medical practitioners spotted the public health emergency. Food and drink adulteration was certainly not new, but this was on a different scale. But why did it happen and why this locality? One thing is clear, it devastated the local brewing industry, which had to make huge strides to recover.

Two factors delayed its detection and prevention. First, brewers did not realise that they were poisoning their customers. Second, doctors misdiagnosed cases. This was due to ignorance and prejudice as working-class people were assumed to be drunk rather than ill. Also, it was no secret that barley malt used by brewers contained elements of arsenic. So, the problem was not news until it emerged in the late 1800s as an epidemic on a far more serious scale. Questions were finally raised and a serious outbreak of arsenic poisoning through contaminated sugar used in the brewing process was

revealed. This was no minor case of adulteration but a catastrophic error. The problem proved devastating to brewers who were seen as the culprits in not only the poisoning but in generally failing to identify and prevent such incidents. Geographically, it went beyond the confines of the Manchester area, spreading across the North West and Midlands. Investigations revealed that poisoned beer on a low-level scale had been allowed for some time, but the situation that presented itself was of such severity that it demanded serious intervention. The correct diagnosis, and the elimination of an alcoholic neuritis, ended a condition that had affected many and had filled Manchester's hospitals for years. Once victims had stopped drinking contaminated beer their health immediately improved.[1]

The *British Medical Journal* of 24 November 1900 reported that half of all outpatients at Ancoats Hospital displayed symptoms. Mill Road Infirmary in Liverpool also saw a massive rise in cases during 1900. Both these areas had a working-class drinking culture in common and illness was misinterpreted as drunkenness. The patients who were vocal in their protestations that their drinking was too moderate never even raised alarm bells, such was the disbelief. The attitude of the medical profession towards Manchester's working class was typical of the time. Here we see, for example, Dr Kelynack of Manchester Royal Infirmary claim to the Society for the Study of Inebriety in 1901, 'I have long been in the habit of teaching that either the drinking habits of the people or the character of the drinks taken led to more distinct pathological results in Manchester and district than elsewhere.'[2] The stigma surrounding the drinking habits of Manchester's working class resulted in a serious problem that was overlooked for some time.

Samples that were taken from Groves & Whitnall at the Regent Road Brewery confirmed that the sugar supplied by Bostock & Co. of Liverpool contained arsenic. Further tests revealed that arsenic was in sulphuric acid used in sugar production, which had been supplied by Nicholson & Sons of Leeds. The Medical Officer for Health in Manchester estimated that by December 1900 up to 2,000 people in Manchester had been affected.[3] The spotlight shone on Groves & Whitnall partly because of inquest testimony of three women, including that of Mary Dyer, who had consumed their beer at the Black Mare pub in Ancoats.[4] Unsurprisingly, the brewery was instrumental in helping the industry out of the crisis since they faced financial ruin, first because they had to rid themselves of all existing stocks of beer, and second, the loss of consumer confidence reduced beer sales. James Grimble Groves instigated a meeting of the Manchester Brewers Central Association on 23 November to assist the authorities.

Surely, they were not the only brewer affected? The principal breweries involved, starting with Groves & Whitnall, reacted immediately by recalling their beer from public houses, destroying contaminated beer (some say that it was poured into the River Irwell, but this was never proven), and testing new brews. In some cases, the beer was set aside to be poured away later in the presence of the excise officers so that the brewery could claim a refund on the duty paid. Breweries in places such as Liverpool and Birmingham took similar measures. Groves & Whitnall destroyed as many as 10,000 barrels since their company's name was particularly associated with the poisoning. Even Manchester brewers had initially thought that the problem was

James Groves of Groves & Whitnall. (Courtesy of Anthony Groves)

specific to the Regent Road Brewery before realising that it was a much wider issue. Groves & Whitnall had all their brews analysed, and a certificate was attached to each barrel. Wilsons was also badly affected and destroyed over 1,200 barrels.[5] In all, Bostock & Co. supplied sugar to around 200 brewers.[6] Dr Kelynack of Manchester Royal Infirmary and William Kirkby of Owens College published their analysis in *Arsenical Poisoning in Beer Drinkers,* concluding that:

> Peripheral neuritis is unfortunately a very common affection in Lancashire amongst alcoholics, and for at least twenty years has been a prolific cause of paralysis. The subjects affected are almost invariably beer drinkers. Some observers go so far as to claim that peripheral neuritis never develops simply in spirit drinkers. Many cases, however, have certainly occurred in imbibers of 'mixed drinks'.[7]

At the subsequent hearing on the scandal, the brewers who appeared as witnesses in addition to James Grimble Groves included Richard George Hooper Tomson of Threlfalls Brewery Co. Ltd, W. R. Deakin of the Manchester Brewery Co. Ltd, Henry Weld Blundell, chairman of the Cornbrook Brewery Co. Ltd, and George E. Cowell, managing director of Wilsons Brewery Co. Ltd. It was estimated that by the end of the crisis those affected had increased to around 6,000 resulting in over seventy deaths, but given the lack of awareness for much of the time surrounding this problem, the reality could have been much higher.[8]

The Decline of the Pub

On 4 July 2022, the BBC announced that the public house had suffered a serious decline and that 7,000 pubs nationally had been lost between 2012 and 2022.[9] In part, this was a consequence of the Covid-19 pandemic, which badly affected the hospitality sector over the two years from 2020 with virtual non-existent business, followed by rising energy prices and the cost of a pint deterring customers that were facing a cost-of-living crisis. However, this is part of a trend in the decline of pubs over the twentieth century more broadly, where the sector has had to constantly reinvent itself to survive, particularly in the wake of changes in leisure patterns and the way alcohol is consumed. A similar debate occurred at the turn of the twentieth century. The chairman of Wilsons Brewery, who commented in a 1907 edition of the *Brewing Trade Review*, estimated that within three years over 300 pubs had been closed in the city.[10] The scramble for pub properties during the 1890s was unsustainable. Brewers had reputations to upkeep, and many were now responsible to shareholders. The turn of the twentieth century presented difficulties for working-class living standards and a decline in the consumption of beer. Some blamed the influence of the temperance lobby that was prominent at this time. The government and brewers were in dispute over two issues. First, there was the thorny issue of compensating breweries for redundant licences. Second, high taxation on the industry was having a profound effect. In particular, the 1904 Licensing Act aimed to reduce the number of licensed houses. The decrease in demand for drink and legislation to bring down the number of pubs weighed heavily on the industry. The Act created a compensation

fund to pay off landlords whose licences were not renewed, and this was funded by a levy on every public house. Brewers were forced to update pub premises since many needed costly repairs, which proved too much of a financial burden for companies that had amassed properties during the latter part of the nineteenth century, especially for those who hastily purchased properties that needed considerable renovation. The Liberal governments before the First World War were influenced by the temperance lobby within the Liberal Party, whose policy made it more difficult to obtain a licence. There was certainly a reduction of pub properties in areas where they were deemed superfluous, having a profound effect in working-class urban areas. The Licensing (Compensation) Act of 1904 affected places such as Salford's old quarter around Chapel Street and Greengate, where many properties were not only of poor condition but allegedly attracted a 'low class' of drinker which exacerbated drunkenness and resulted in social disorder. The Act also had a similarly detrimental impact on Hulme, which also lost hundreds of establishments. Bargaining of licences became common between brewers and authorities. This resulted in the surrender of one licence to allow a new build or upgrade for another pub, and we see this with brewers such as James Kay, Walker & Homfrays, and Wilsons, who all owned pubs in Hulme.[11]

The economic depression of the 1930s and a further world war increased pressures on an already struggling industry. Then came along social and cultural change, where attractive alternative forms of leisure challenged drink culture and activities such as football, cinema and film, radio and television, and seaside holidays enticed working-class people away from spending their cash solely on drink. Post-war reconstruction heralded the arrival of slum clearances and compulsory purchase orders that reduced the number of tied houses that brewers relied upon to service outlets with their beer. In some communities, the effect of this was as shocking as it was swift.

Despite the problems brewers faced managing large portfolios of properties, it was still regarded as the most viable business model since pub ownership guaranteed outlets for their beers and a general expectation that the tied-house system would offer some market security even in the worst years of economic depression.[12] However, was this best intention in hindsight misguided? The years following the Second World War, particularly during the 1950s and 1960s, severely tested this business strategy. Local authorities were keen to redevelop and modernise communities, and with this came the compulsory purchase of properties. It was ironic that the one institution that brought communities together struggled to survive this new modernisation when housing stocks were demolished to make way for new developments, which included the removal of many local pubs. The relationship between brewers and authorities in the compulsory purchase of pub properties became contentious and costly. Salford and the areas around Hulme were profoundly impacted. At the turn of the twentieth century, there were up to 200 pubs in Salford. Of these, about ten survived different stages of redevelopment into modern times. The area around Hanky Park, for example, had around fifty pubs across its 7 or so acres. Many of the buildings were admittedly in very poor condition and some of the pubs were selling so little beer it was difficult to justify their survival. A public inquiry in 1950 examining Salford's slum-clearance scheme interviewed some of those affected, including eighty-year-old George Turton

who for forty-five years had occupied the Stephen's Tavern, and did not want to move despite Salford's authorities condemning his premises. It was both his home and business and held a lifetime of memories. Edith Chadderton ran an off-licence in Brewery Street, having been born there forty-one years earlier, and argued that there was nothing wrong with the property.[13]

The contention that there were too many pubs in Manchester and Salford, particularly ones that were barely making a living, surfaced again at the 1954 Licensed Retailers Association's annual banquet with the Mayor of Salford, Joseph Shlosberg, vocal in his view that a ballot should be held to decide which ones to keep open. While a controversial and not very practical option, there was consensus that publicans and brewers faced difficulties and slum clearance, especially when pubs remained standing in desolate areas where their customers had left.[14] The problem for the authorities was the level of compensation that was being paid out to brewers. The financial commitment was mounting and even starting to affect wider rents to recoup costs. Often compensation did not reflect the turnover of pubs.[15] Specifically, Salford Council was facing a bill of £280,000 for the compensation of twenty-nine public houses. One councillor, Alderman Goulden, stated that in an area of demolition, nine pubs were standing 'like sentinels in the desert' with little or no custom and hampering wider housing redevelopment. A total of £64,000 had already been paid out on nine houses with another twenty in the pipeline. Council members felt that brewers were given preferential treatment and pubs were being valued more generously than other businesses, obtaining both compensation and good sites for new pubs. Shopkeepers, for example, were given compensation based on the previous six months of trading, seemingly little in comparison with the generosity brewers were receiving, often for dilapidated properties not worth saving.[16] At a 1959 public inquiry there was a dispute over the condition of some pub properties. The Red Lion and Miners Arms were examples where they were originally seen as unfit for habitation, but brewers were accused of renovating pubs just enough to allow them to seek a higher level of compensation. There was also a disagreement over how much brewers had spent to make their pubs viable businesses.[17] Unsurprisingly, brewers were of a different opinion. For example, Groves & Whitnall lost three pubs and three off-licences in 1960, and a further twenty pubs and eleven off-licences, the losses of which, in their opinion, would take some time to absorb.[18] It has been estimated that two to three pub licences were lost for the gain of just one. This meant that brewery losses were mounting, so those that lost properties selling the most beer were offered the first refusal of new sites.[19] One of the more famous pubs lost in Salford was the William IV in East Ordsall Lane, owned by Manchester-based Joseph Holt, which closed in 1960 to make way for the Islington redevelopment, with, as mentioned earlier, the bar forming part of the 'Rovers Return' in the long-standing soap *Coronation Street*.[20]

The area around Ellor Street was severely affected by compulsory purchase and on 28 April 1963, coined 'Black Sunday', seven of the eight doomed pubs closed their doors for the last time, including the Miners Arms, British Queen, and the Oddfellows. They were indeed 'like sentinels in the desert' as the only buildings standing after the

demolition of the surrounding neighbourhoods. Some have even claimed that workers undertaking the demolition work left pubs until the very last moment, so they had somewhere to drink! Many former customers came from their new neighbourhoods up until this last weekend in a sense of loyalty that these tight-knit communities often displayed. The British Queen dated back to the 1850s. It was acquired by a compulsory purchase order in early 1960, as part of the Ellor Street clearance, serving its last pint at the lunchtime session on Black Sunday. The *Salford City Reporter* noted, 'The pumps were empty and the bottle shelves were bare ... Like islands in a sea of rubble.'[21]

The Miners Arms was another casualty that fateful weekend in 1963. The pub's final licensee was Elsie Walters, for whom the closure must surely have been a wrench at the age of seventy-two and after fourteen years in charge. A compulsory purchase order had been served in 1959, so she had been living with the threat of pub closure for some years before it happened. In an interview with the *Salford City Reporter* a few days before Black Sunday, Mrs Walters said, 'I'm lucky if I can fill a table on weekdays, but they're very loyal on Saturday nights; some of them come a five-penny bus ride to drink here again. But the ladies don't like coming down from Broad Street, with no streetlights and all the bricks.'[22] The Oddfellows Arms followed a similar line. A former beerhouse from the 1840s, by the turn of the twentieth century it was owned by Groves & Whitnall. The pub had been up for closure back into the first decade of the twentieth century when in 1908 the authorities decided it was not viable with so few customers and in such poor condition. Groves & Whitnall invested in the house and it survived until 1965 when it succumbed to the Ellor Street clearance. So, was the removal of these pubs worth it? Of the nine or so that were built in the 1970s to replace some of the losses, only the Winston has survived to date, some only surviving twenty years or so.

There are other similar examples in Manchester. The Cheshire Cheese public house was one of the first properties to be acquired as part of Hulme's compulsory purchase-order scheme. The pub had been in existence since the middle of the nineteenth century but succumbed to redevelopment just over a century later in 1957.[23]

Another example is that of the Lord Clyde public house. While this survived compulsory purchase in the immediate post-war era, it went on until the 1980s when there was another reshaping Manchester's working-class districts. At this time, many terraced streets and local pubs once again fell victim to modernity and were replaced with high-rise flats which fell far short of the dream they set out to be, destroying local communities in the process. One observer wrote in the *Manchester Evening News* in 1958, 'I wonder how many readers have noticed what charmed lives pubs seemed to lead compared to houses. All over the place, despite the blitz and slum clearance pubs have survived and now stand in comparative isolation in all their glory.'[24] It was ironic that new pubs that were built in communities were not always an instant success. For example, on the twenty-first anniversary of the development of Wythenshaw in 1951, it was reported that residents 'found themselves in newly painted homes of pleasant design, but no nearby cinema and pubs so luxurious in comparison to their "local" that they were afraid to enter for a time'.[25]

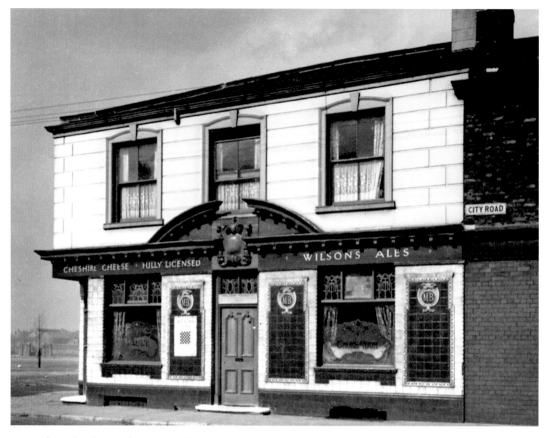

The Cheshire Cheese public house in Hulme during the post-war slum clearance. The effect of the clearance can be seen in the background. (Courtesy of Manchester Local Studies & Archives)

Microbrewery Mania

Since the 2010s there has been a resurgence of smaller-scale brewing, craft, or microbreweries. CAMRA (the Campaign for Real Ale) has worked hard to bring traditionalism and localism back into the industry since around 1970 and has campaigned against large conglomerate brewers dominating the industry.[26] Interestingly, the domination of both multinational brewers and the resurgence of local craft brewing remains strong. The shift in this type of brewing arguably has much to do with a renaissance of localism – offering a local and unique taste and supporting local business. The return of smaller-scale and locally produced beer has also created urban regeneration in railway arches and disused industrial premises in places like Manchester and Salford. At the same time, their drinking venues are often quite different to the traditional public house, again using often converted disused spaces rather than incurring the costs associated with conventional pub premises. This results in the production and consumption of the beer occurring in the same place, offering beer drinkers a new and interesting experience in brewery taps. These breweries also have a thriving online market for their beer, which was a particular advantage when

the Covid-19 pandemic negatively impacted the hospitality trade in 2020. In this section we are going to examine some of the smaller localised breweries in the cities and their influence on the local brewing industry.

One of the first microbreweries in Manchester, Marble Beers, has been very successful since its inception in 1997 and celebrated its twenty-fifth anniversary in 2022. Their brewery began in what is still their spiritual home if not their physical one, at the Marble Arch public house on Rochdale Road. Here they had a microbrewery behind glass that fascinated customers, and which provided a great deal of interest while consuming a pint. They eventually set up in some railway arches nearby in Angel Meadow in 2009, and a decade later relocated again, this time to a modern unit close to MediaCity in Salford. Their emphasis on organic and vegan products is popular with those who wish to support more sustainable and environmentally friendly beer production. There was a rash of microbreweries emerging between 2012 and 2015. These included the Blackjack Brewery, a short walk away from Marble Beers and also located in an Angel Meadow railway arch. Starting in 2012, they own a few public

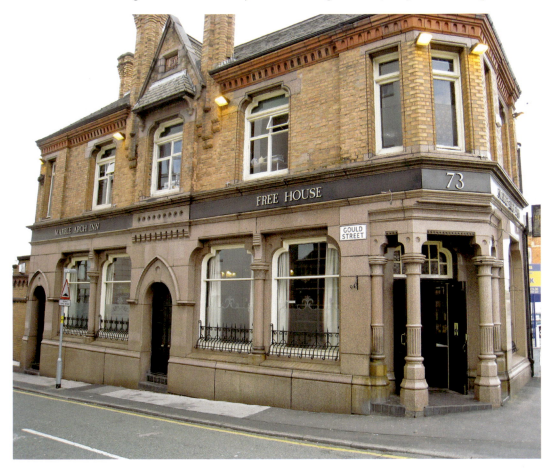

The Marble Arch public house, the origins of Marble Brewery. (Courtesy of Bernt Rostad, Flickr)

houses that serve its beer, including the Smithfield Tavern, a short walk away from the brewery. It also operates market taps in places such as Manchester, Macclesfield, and Altrincham. During the summer months, it operates popular evenings at its brewery tap, with street food and popular music, which attract a loyal crowd. The arrival of Blackjack was quickly followed by another new company, the Shindigger Brewing Company. Established by two former University of Manchester students, they commenced business at the end of 2012. Located just off Trinity Way on the Manchester–Salford border, they offer American-inspired beers, incorporating flavours such as peach, tropical fruits, and even iced coffee.

In 2013, the Seven Bro7hers Brewery was established and, as its name implies, is operated by seven brothers that make up the McAvoy family. They have a brewery and tap in Salford and beerhouses across Manchester, Salford, and Liverpool. In 2023, they merged with FOUR SIS4ERS (again literally four sisters, also of the McAvoy family), which began in 2018 and operates a distillery, to form one of the largest family-run businesses in the brewing industry and to extend their products to the likes of gin and rum.

From 2014, Manchester saw the arrival of more small breweries. The Cloudwater Brew Company is located at an industrial unit, with their brewery taps in Piccadilly in Manchester and a railway arch in Bermondsey in London. The unique selling point of Cloudwater beer is the seasonality of its offerings, such as Christmas Cake stout. One of its founders, James Campbell, was the former head brewer at Marble Beers. In 2021, they opened the Sadler's Cat pub near Victoria station and a beer hall on Minshull Street as part of the Kampus urban living development. Finally, Track Brewing Company moved from their former railway-arch home in Piccadilly to a nearby industrial unit in 2021, and again you can drink where the beer is brewed. The Runaway Brewery began business in 2014 and up to 2023 was located just off Dantzic Street in Angel Meadow, though it has recently relocated to a former sheet-metal-works premises in Stockport. Runaway brews beers by hand in small batches in the centre of Manchester they describe as 'internationally influenced but recognisably British', with their core specifically Pale Ale, IPA, American Brown Ale, and Smoked Porter. Pomona Island Brewing Company, located in Salford close to the Seven Bro7hers Brewery, began in 2017 and has bars around Manchester. Manchester Union Brewery is a dedicated craft-lager brewery located in Ardwick that began in around 2018. Like other breweries, they are based in a former railway arch, in North Western Street. By their own admission, they offer central European brewing techniques with a Mancunian twist.

More recent businesses include the Hideaway Brewery, which began during the Covid-19 pandemic, and Bundobust Brewery, which began in 2021. Bundobust has a brewery at Manchester Piccadilly that combines their restaurants specialising in Indian cuisine with their beer; they have restaurants across the North West in Liverpool, Manchester, and Leeds. The Scottish brewer BrewDog has a pub and brewery on the University of Manchester campus at the corner of Oxford Road and Booth Street, offering a unique brewing and drinking experience on the same site. Another university campus brewing experience is that of ÖL at Hatch, which is tucked away and housed

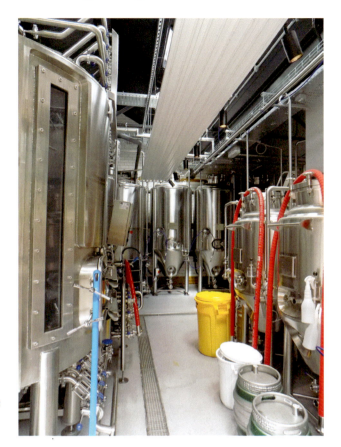

Right and below: Lark Hill Brewery in Salford's old fire station, giving new life to a redundant space.

in a shipping container under the Mancunian Way on the Manchester Metropolitan University campus on Oxford Road. It is termed a nanobrewery – or one that brews a particularly small amount of beer. Its theme is that of Nordic craft and quality and its beer includes onsite production of brews such as the best party cacao, vanilla, coffee, and coconut imperial stout and A Thing or Two session IPA.

Success is not always easy to achieve, especially in an increasingly crowded microbrewery market, and the Covid-19 pandemic and subsequent cost-of-living crisis has had a devastating impact on local hospitality. Many smaller brewers have struggled to survive and there have been casualties. These include Beatnitz Republic, which announced its closure in April 2022. They began in 2017 and opened their first bar in 2018, but recent events have proven too much for the business. The bar has been taken on by another craft brewer, Squawk. The Alphabet Brewing Company, which began in 2014 but announced its closure in 2023, was another railway-arch brewery that offered hoppy and fruity beers at their brewery tap in nearby Ardwick. They produced a few 'signatures', as it were, including Juice Springsteen tropical IPA, Hoi Polloi pilsner and their Flat White stout.

In 2023, a new microbrewery appeared, ironically just around the corner from where the Joule family lived over 200 years earlier. The University of Salford opened Lark Hill Brewery in what was Salford's old fire station and the space that once housed fire engines is now home to the brewing paraphernalia and a brewery tap, along with a new bakery next door. The name has historical links to the area with the former Lark Hill residence, which today houses Salford Museum and Archives, just across the road. Maybe this is the trend going forward and reinforces the concept of small-scale brewing popping up in redundant spaces and a drink culture that is not in the traditional public house but in this case an old fire station! The support from and collaboration with the nearby Marble Brewery illustrates cooperation as much as competition in the local microbrewery sector.

Conclusion

The story has come full circle, from a single publican brewer that was the beginning of the brewing story in the region, through to the emergence of commercial brewers, takeovers, tie-in of houses, and larger conglomerates, followed by a resurgence of traditional beer produced by microbreweries providing a return to localism. The brewing journey in Manchester and Salford began with the likes of what became Boddingtons and the Joule family, who were the first to develop large-scale brewing. At the time they began their operations, they were bucking the trend when most beers were produced by single publican brewers on their own premises. The 1830 Beer Act provided a catalyst for brewing on a larger commercial scale since many beerhouses did not have the resources to brew the volumes required. During the nineteenth century, several other famous names appeared on the local brewing scene, such as Joseph Holt, Hydes, Wilsons, Threlfalls Chesters, and Groves & Whitnall. The industry spun out of control in the takeover of one brewery by another and the acquisition of pubs to secure a market for their beer in an ever-competitive market. By the 1890s, this process was at its pinnacle as many breweries became limited companies and open to shareholders

in a bid to raise funds to develop the quality and quantity of beer and properties. The pace was unsustainable and by the early twentieth century, further legislation to keep the industry in check was also followed by two world wars and the subsequent urban regeneration and slum clearances which saw many dilapidated pub properties disappear.

Some big local brewing names were also lost from the mid-twentieth century onwards, with Groves & Whitnall consumed by Greenall Whitley & Co., Threlfalls Chesters becoming part of Whitbread, Boddingtons falling victim to Interbrew, and Wilsons amalgamation with Watney Mann and ultimate disappearance. Yet, those who maintained their independence still survive – Joseph Holt, Hydes, J. W. Lees, and Robinsons. These, along with a surge in microbrewing, and despite a pandemic that badly affected the hospitality industry, the desire for a drink of beer, and the craftsmanship that goes into it, remain as strong as ever.

Notes

Chapter 2
1. E. Raffald, *The Manchester Directory* (1773); *Lewis's Directory for the Towns of Manchester & Salford for the Year 1788* (1788); *Scholes' Manchester & Salford Directory* (1797).
2. N. Richardson, *The Old Pubs of Ancoats* (1987), pp. 9, 23.
3. *Manchester Courier & Lancashire General Advertiser*, 24 March 1860, 21 April 1860, 28 April 1860.
4. T. R. Gourvish and R. G. Wilson, *The British Brewing Industry 1830–1980* (1994), Ch. 3, table 3.2.
5. *Wheeler's Manchester Chronicle*, 4 June 1825.
6. Richardson, *The Old Pubs of Ancoats*, pp. 30, 26.
7. *Manchester Courier & Lancashire General Advertiser*, 10 March 1860.
8. N. Hyde, *Brewing Was a Way of Life – The Story of Hydes' Anvil Brewery, Manchester* (2005), p. 27.
9. S. Smith, *The Memoirs of the Reverend Sydney Smith* (1855), Vol. 2, p. 355.
10. S. and B. Webb, *The History of Liquor Licensing in England Principally from 1700 to 1830* (1904), p. 49.
11. K. Hawkins and C. Pass, *The Brewing Industry* (1979), pp. 28–30.

Chapter 3
1. jwlees.co.uk/about.
2. L. Richmond and A. Turton, *The Brewing Industry: A guide to historical records* (1990), pp. 207–8.
3. A. Barnard, *The Noted Breweries of Great Britain & Ireland* (1889), Vol. 4, p. 461.
4. *Manchester Courier & Lancashire General Advertiser*, 26 June 1906.
5. A. Gall, *Manchester Breweries of Times Gone By* (1981), Vol. 1, p. 8.
6. *Manchester Courier & Lancashire General Advertiser*, 3 July 1907.
7. jwlees.co.uk/about.
8. R. Protz, *The Family Brewers of Britain* (2020), location 2250.
9. jwlees.co.uk/beer/moonraker.

10. *Manchester Evening News*, 14 July 1886.
11. Richmond and Turton, *The Brewing Industry*, p. 283; Gall, *Manchester Breweries*, Vol. 2, pp. 13–15.
12. N. Richardson, *A History of Wilsons Brewery, 1834–1984* (1984), pp. 1–3.
13. breweryhistory.com/wiki/index.php? title=Wilsons_Brewery_Ltd.
14. Richardson, *A History of Wilsons*, pp. 21–23.
15. Richardson, *A History of Wilsons*, p. 4.
16. Gall, *Manchester Breweries*, Vol. 1, p. 1; *Manchester Times*, 9 January 1875.
17. *Manchester Courier & Lancashire General Advertiser*, 6 July 1899.
18. *Manchester Courier & Lancashire General Advertiser*, 4 August 1900.
19. breweryhistory.com/wiki/index.php? title=Swales_%26_Co._Ltd.
20. Richardson, *A History of Wilsons*, p. 5.
21. *Manchester Courier & Lancashire General Advertiser*, 26 March 1900; Gall, *Manchester Breweries*, Vol. 1, pp. 14–16.
22. Richardson, *A History of Wilsons*, pp. 2–5.
23. Richardson, *A History of Wilsons*, pp. 5–11.
24. *Manchester Courier & Lancashire General Advertiser*, 12 August 1895.
25. Richardson, *A History of Wilsons*, pp. 14–15.
26. Richardson, *A History of Wilsons*, pp. 18–20.
27. *Manchester Courier & Lancashire General Advertiser*, 1 July 1895, 2 July 1896.
28. *Manchester Courier & Lancashire General Advertiser*, 3 October 1896.
29. N. Richardson, *A History of Joseph Holt* (1984), p. 1.
30. joseph-holt.com/history-timeline; *Whellan & Co. Trade Directory for Manchester & Salford* (1853).
31. Richmond and Turton, *The Brewing Industry*, pp. 184–85.
32. Richardson, *A History of Joseph Holt*, p. 2.
33. Boddingtons Archive, MCRL (1862–1890), M693/405/13 and M693/405/70.
34. *Manchester Courier & Lancashire General Advertiser*, 14 October 1905.
35. joseph-holt.com/history-timeline.
36. Protz, *The Family Brewers of Britain*, location 2613.
37. Richmond and Turton, *The Brewing Industry*, pp. 184–85.
38. Richardson, *A History of Joseph Holt*, pp. 18–19; joseph-holt.com/history-timeline.
39. Protz, *The Family Brewers of Britain*, location 2629.
40. joseph-holt.com/history-timeline.
41. Protz, *The Family Brewers of Britain*, location 2527.
42. *Bancks's Manchester & Salford Directory* (1800); M. Jacobson, *200 Years of Beer: The Story of Boddingtons' Strangeways Brewery 1778–1978* (1978), p. 11.
43. *Manchester Courier & Lancashire General Advertiser*, 28 November 1905.
44. Jacobson, *200 Years of Beer*, pp. 17–20; Gourvish and Wilson, *The British Brewing Industry*, p. 34.
45. *Manchester Courier & Lancashire General Advertiser*, 28 November 1905.
46. Boddingtons Archive (1862–1890), M693/405/13.
47. Jacobson, *200 Years of Beer*, p. 42.

48. *Manchester Courier & Lancashire General Advertiser*, 21 August 1886.
49. Gourvish and Wilson, *The British Brewing Industry*, p. 41.
50. Jacobson, *200 Years of Beer*, p. 64.
51. Boddingtons Archive (1862–1890), M693/405/13 and M693/405/70.
52. Jacobson, *200 Years of Beer*, p. 39.
53. Boddingtons Archive (1862–1890), M693/405/13 and M693/405/70.
54. Richmond and Turton, *The Brewing Industry*, pp. 75–76.
55. L. Pearson, *Built to Brew: The History & Heritage of the Brewery* (2014), p. 206.
56. Jacobson, *200 Years of Beer*, pp. 42–56.
57. Gall, *Manchester Breweries*, Vol. 2, pp. 8–9.
58. Richmond and Turton, *The Brewing Industry*, pp. 75–76.

Chapter 4
1. F. Cowen, *A History of Chesters Brewery Company* (1982), pp. 2–4.
2. *Manchester Courier & Lancashire General Advertiser*, 5 February 1853.
3. Cowen, *A History of Chesters*, p. 2.
4. B. Glover, *The Lost Beers & Breweries of Britain* (2012), location 644.
5. Cowen, *A History of Chesters*, p. 6.
6. Richmond and Turton, *The Brewing Industry*, p. 102.
7. Glover, *The Lost Beers*, location 611.
8. Cowen, *A History of Chesters*, p. 8.
9. *Manchester Courier & Lancashire General Advertiser*, 26 March 1895.
10. Cowen, *A History of Chesters*, p. 10.
11. Cowen, *A History of Chesters*, p. 22.
12. *Manchester Courier & Lancashire General Advertiser*, 29 September 1888.
13. Gall, *Manchester Breweries*, Vol. 2, pp. 3–4.
14. *Manchester Courier & Lancashire General Advertiser*, 7 October 1897.
15. *Manchester Mercury*, 17 May 1791; *Scholes' Manchester & Salford Directory* (1797); *The Manchester & Salford Directory* (1800).
16. *Nottinghamshire Guardian*, 17 April 1868.
17. *Slater's Directory for Manchester & Salford* (1869); *Kelly's Trade Directory for Manchester & Salford* (1873); Richmond and Turton, *The Brewing Industry*, pp. 115–16.
18. *Manchester Evening News*, 3 April 1941.
19. *Manchester Evening News*, 17 January 1989.
20. *Manchester Courier & Lancashire General Advertiser*, 4 August 1888.
21. breweryhistory.com/wiki/index.php? title=List_of_Hardy%27s_Crown_Brewery_Ltd_Pubs.
22. *Manchester Courier & Lancashire General Advertiser*, 9 December 1896.
23. *Slater's Directory for Manchester & Salford* (1841).
24. *Manchester Courier & Lancashire General Advertiser*, 8 June 1844; *Manchester Courier & Lancashire General Advertiser*, 4 April 1846.
25. Gall, *Manchester Breweries*, Vol. 1, pp. 12–13.
26. *Manchester Courier & Lancashire General Advertiser*, 5 October 1861.

27. *Manchester Courier & Lancashire General Advertiser*, 8 January 1874.
28. A. Gall, *What's Doing – The Manchester Beer Drinkers Monthly Magazine* (1980), March edn.

Chapter 5
1. N. Hyde, *Brewing Was a Way of Life – The Story of Hydes' Anvil Brewery, Manchester* (2005), p. 145.
2. Hyde, *Brewing Was a Way of Life*, p. 13.
3. Hyde, *Brewing Was a Way of Life*, p. 20.
4. Hyde, *Brewing Was a Way of Life*, pp. 146–47.
5. Hyde, *Brewing Was a Way of Life*, pp. 18–20.
6. Hyde, *Brewing Was a Way of Life*, p. 91.
7. Hyde, *Brewing Was a Way of Life*, p. 32.
8. Hyde, *Brewing Was a Way of Life*, p. 35.
9. Richmond and Turton, *The Brewing Industry*, p. 190.
10. Hyde, *Brewing Was a Way of Life*, pp. 55–99.
11. Hyde, *Brewing Was a Way of Life*, p. 105.
12. Richmond and Turton, *The Brewing Industry*, p. 190; Hyde, *Brewing Was a Way of Life*, p. 66.
13, Gall, *Manchester Breweries*, Vol. 2, pp. 19–21.
14. *Manchester Evening News*, 7 January 1972.
15. *Manchester Evening News*, 16 June 2018.
16. *Manchester Courier & Lancashire General Advertiser*, 18 September 1880.
17. breweryhistory.com/wiki/index.php? title=Empress_Brewery_Co._Ltd.
18. *Manchester Courier & Lancashire General Advertiser*, 24 July 1901.
19. *Liverpool Daily Post*, 30 September 1930.
20. Protz, *The Family Brewers of Britain*, location 2453.
21. Protz, *The Family Brewers of Britain*, location 2481.

Chapter 6
1. joulesbrewery.co.uk/our-story.
2. A. Gall, 'James Joule: Brewer and Man of Science', *Brewery History* (2004), 115, pp. 2–6.
3. joulesbrewery.co.uk/our-story.
4. *Manchester Courier & Lancashire General Advertiser*, 16 March 1888.
5. *Slater's Trade Directory for Manchester & Salford* (1863).
6. *Manchester Courier & Lancashire General Advertiser*, 16 March 1888.
7. *Manchester Evening News*, 4 February 1907.
8. *Manchester Courier & Lancashire General Advertiser*, 16 March 1888.
9. *Manchester Evening News*, 4 February 1907.
10. Gall, *Manchester Breweries*, Vol. 2, p. 1.
11. *Manchester Courier & Lancashire General Advertiser*, 4 February 1905, 14 July 1906.
12. Gall, *Manchester Breweries*, Vol. 2, pp. 10–11.
13. Glover, *The Lost Beers* (Kindle edn), location 595.

14. *Pigot & Co. National Commercial Directory* (1834).
15. J. Groves and K. Groves, *The History of a Brewery, 1835–1949: the history as a partnership and as a Ltd company of the House of Groves & Whitnall issued to its stockholders and members during its golden jubilee year as a Ltd company* (1949), p. 1.
16. Boddingtons Archives, GB127 M693/405.
17. Groves and Groves, *The History of a Brewery*, p. 2.
18. *Manchester Courier & Lancashire General Advertiser*, 7 May 1901.
19. Barnard, *The Noted Breweries*, Vol. 3, p. 186.
20. Barnard, *The Noted Breweries*, Vol. 3, p. 186.
21. salfordladsclub.org.uk/about/history/.
22. Barnard, *The Noted Breweries*, Vol. 3, p. 199.

Chapter 7
1. M. Copping, 'Death in the beer-glass: the Manchester arsenic-in-beer epidemic of 1900–1 and the long-term poisoning of beer', *Brewery History* (2009), 132, pp. 31–32.
2. Copping, 'Death in the beer-glass', p. 34.
3. Copping, 'Death in the beer-glass', pp. 38–39.
4. *Manchester Evening News*, 9 January 1901.
5. P. Dyer, 'The 1900 Arsenic Poisoning Epidemic', *Brewery History* (2009), 130, pp. 65–85.
6. *Manchester Evening News*, 9 January 1901.
7. Dyer, 'The 1900 Arsenic Poisoning Epidemic', pp. 65–85.
8. Copping, 'Death in the beer-glass', pp. 46–67.
9. bbc.co.uk/news/business-62031833.
10. Gourvish and Wilson, *The British Brewing Industry*, p. 291.
11. B. Potts, *The Old Pubs of Hulme and Chorlton-on-Medlock* (1997), p. 5.
12. Hawkins and Pass, *The Brewing Industry*, pp. 1–2.
13. *Manchester Evening News*, 29 November 1950.
14. *Manchester Evening News*, 5 March 1954.
15. *The Guardian*, 8 May 1958.
16. *The Guardian*, 7 April 1960.
17. *The Guardian*, 9 September 1959.
18. *The Guardian*, 13 April 1961.
19. Cowen, *A History of Chesters*, p. 28.
20. Richardson, *A History of Joseph Holt*, p. 23.
21. N. Richardson, *Salford Pubs* (2003), location 1040.
22. Richardson, *Salford Pubs*, location 1259.
23. manchestereveningnews.co.uk/news/nostalgia/gog-magog-druids-arms-manchester-21710705 (7 October 2021).
24. *Manchester Evening News*, 25 August 1958.
25. *Manchester Evening News*, 31 August 1951.
26. camra.org.uk/about/about-us/our-history/.